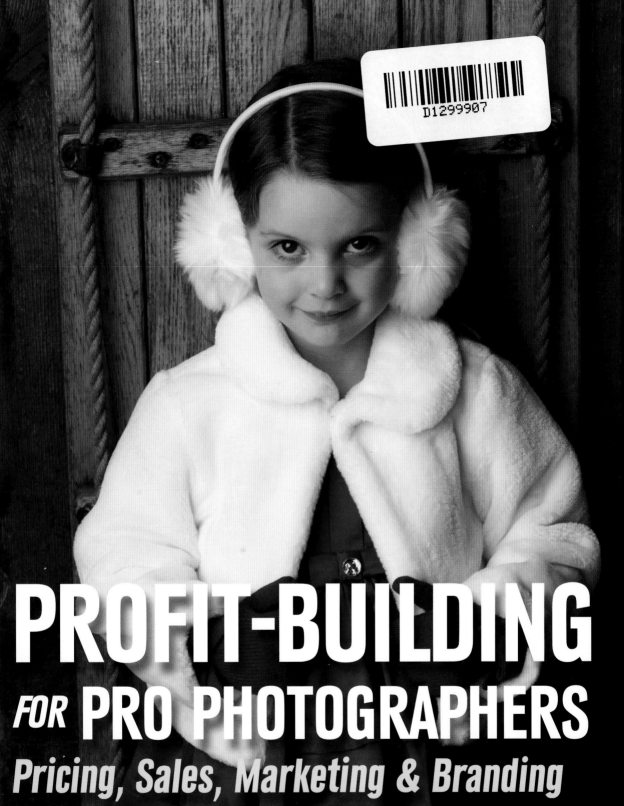

PROFIT-BUILDING
FOR PRO PHOTOGRAPHERS
Pricing, Sales, Marketing & Branding

Jeff Dachowski, *M.Photog.Cr.,CPP* **Carolle Dachowski**, *M.Photog.Cr*

AMHERST MEDIA, INC. ■ BUFFALO, NY

AUTHOR A BOOK WITH AMHERST MEDIA!

Are you an accomplished photographer with devoted fans? Consider authoring a book with us and share your quality images and wisdom with your fans. It's a great way to build your business and brand through a high-quality, full-color printed book sold worldwide. Our experienced team makes it easy and rewarding for each book sold—no cost to you. E-mail submissions@amherstmedia.com today!

Copyright © 2016 by Jeffrey and Carolle Dachowski
All rights reserved.
All photographs by the authors unless otherwise noted.

Published by:
Amherst Media, Inc., P.O. Box 538, Buffalo, N.Y. 14213
www.AmherstMedia.com

Publisher: Craig Alesse
Senior Editor/Production Manager: Michelle Perkins
Editors: Barbara A. Lynch-Johnt and Beth Alesse
Acquisitions Editor: Harvey Goldstein
Associate Publisher: Kate Neaverth
Editorial Assistance from: Ray Bakos, Rebecca Rudell, Jen Sexton
Business Manager: Adam Richards

ISBN-13: 978-1-60895-989-1
Library of Congress Control Number: 2015944885
Printed in The United States of America.
10 9 8 7 6 5 4 3 2 1

No part of this publication may be reproduced, stored, or transmitted in any form or by any means, electronic, mechanical, photocopied, recorded or otherwise, without prior written consent from the publisher.

Notice of Disclaimer: The information contained in this book is based on the author's experience and opinions. The author and publisher will not be held liable for the use or misuse of the information in this book.

www.facebook.com/AmherstMediaInc
www.youtube.com/c/AmherstMedia
www.twitter.com/AmherstMedia

Contents

Marketing and Promotions

About the Authors

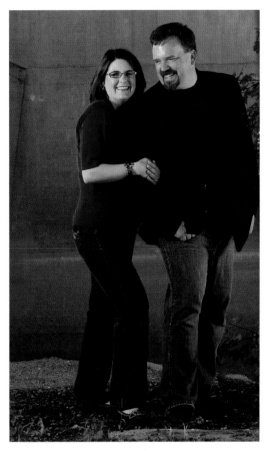

photo by Mark Levesque

Jeffrey Dachowski, M.Photog.Cr.,CPP
Carolle Dachowski, M.Photog.Cr.

Jeff quickly fell in love with photography while he was in high school. After taking every class related to photography, he attended the Hallmark Institute of Photography in Turners Falls, Massachusetts.

Jeff and Carolle own and operate a prosperous studio in the Historic District of Bedford, New Hampshire. They have gained a loyal following of portrait and commercial clients and have striven to tell their subjects' personal stories. They are well known for their photography of babies, children, families, seniors, and weddings and are the recipients of numerous awards, as well as being Vatican approved photographers.

Jeff and Carolle have photographed throughout the Northeast, the Caribbean, and the inter-mountain west since 1992. Their work has been featured in *Seacoast Bride, New Hampshire Bride, Woman Engineer, Hygiene Town, Woman's World, Spin, and Professional Photographer.* They have fifteen images in the PPA Loan Collection, eleven Kodak Gallery Awards, two Fuji Masterpiece Awards, Lexjet, and Polaroid awards and nine Courts of Honor.

They have each been awarded the Master of Photography and Photographic Craftsman Degrees; Jeff is also a Certified Professional Photographer. He is an approved International Juror, a judge for the PPCC and he currently serves on the Board of Directors of Professional Photographers of America.

Jeff and Carolle have been married for twenty-two years and have two lovely daughters.

Pricing and Operations

1 | Introduction to Pricing and Operations

Welcome to *Profit-Building for Pro Photographers: Pricing, Sales, Marketing and Branding!* This book is an investment not only in the cost of this title, but the time it takes in reading and implementation of some of the ideas. Notice we said, *some?* Why not *all* of the ideas? Well…not every idea that has worked for us could necessarily work well for you. The concepts might be sound but need testing and tweaking in your local area. Regional differences might account for the particular success or failure of a particular technique.

When we speak about business to photography groups, we frequently hear a phrase, "That won't work in my area." Although this can be true, it really is signaling a surrender that there is nothing to be done about getting a business off the ground or refining a current business. It almost means that your success is all luck. We believe you are supposed to make your own luck. Of course, things might be different in your community, but we encourage you to take the ideas presented here and apply them to your situation. See if there is a way to implement the part

that might work in your area. Most of our successful pricing strategies and marketing plans are ideas we have seen in other industries and have applied to our own business.

Seldom do we have original ideas. There is no need to reinvent the wheel. Use the strategies and concepts detailed in this book to get your business where you want it to be. Try things several times. Usually it takes a few attempts to really gauge an effort's success. Almost nothing works right away. Do not be discouraged!! Read through a few times, take notes in the margins! We sincerely hope you enjoy this journey half as much as we have enjoyed writing it!

We believe you are supposed to make your own luck.

2 | **Type of Studio**

Before you can determine exactly how to get your photography business to the point of profitability, you must first know what type of business you want to have. There are many types of business models that can work in the photography industry.

High-Volume Studio

This model is ideally suited for photography involving grade schools, middle schools, high schools, dance schools, sports leagues, proms, father daughter dances, and other events or schools. This model generally involves a short amount of time with each subject, a fairly low price point, but a profit margin that is fairly high. It relies on the ability of the photographer to connect with the subject quickly and to photograph many subjects per day. Consistency is the key to success in this model. Creativity and personal artistic satisfaction can be low in this industry. This is an important part of our industry as it creates memories for millions of people and the lower price point allows clients with limited resources to participate and acquire professional imagery for their children. We believe this segment of our industry helps to feed a desire for the lower volume market as well.

Low-Volume Studio

Referred to as the carriage trade or boutique studios. This business model is suited for longer sessions with your subjects. Investment time with each session can be four hours and up. Price points are higher as well as the perceived value in the client's mind. Clients typically invest in wall art and albums. Profit margins are similar in their percentages, but as the time investment is higher, the total investment needs to be much higher per session in a low-volume business. The products of this business model are also treasured by future generations. Typically, those who invest in this type of photography have a higher level of disposable income.

Hybrid

This business model involves a studio that leverages both high and low volume to produce the lifestyle they desire. Each segment of the business utilizes a different brand. The separate brands are present as to not confuse the marketplace between the high and low-volume brands. This has become more popular amongst current studios looking to diversify their efforts and increase profits.

Our Studio Model

Our studio business model is closest to the hybrid model. We produce high-quality

photography at both the volume and the commissioned artwork level. We use this model to keep our studio and staff busy year round.

If you are just starting out, we encourage you to choose one direction to follow at first. It is very difficult to lift both business models into profitability at the same time.

There are many types of business models that can work in the photography industry.

3 | How Much Time Can You Commit?

We have consulted with many studios around the country. One of the most common issues that photographers have to work through is time management. We love our craft. In most cases, photographers would work for free, or even pay to work! Apply this if you will to another trade. Let's look are a laborer who loads drywall into buildings. How many hours a day is a laborer available to load drywall for no pay? We are willing to bet it falls somewhere near zero hours per day. Apply that same question to a photographer, and you find many answering ten or more! Maybe they are saying zero hours, but in practice they are literally working a second full-time job for free because they love the craft.

One of the most common issues that photographers have to work through is time management.

The Entrepreneurial Spirit

When working on your business, it is important to determine if you have the entrepreneurial spirit to make photography something more than a hobby. Please don't misunderstand. Hobbies are great. They allow us a creative release that jobs we are paid to do just don't compare to. Frequently, photographer's hobbies are also photography. This poses a problem.

Time Commitment

How much time do you have for your business? If you are finding yourself working into the morning hours, editing, cropping, color correcting, posting to social media, answering e-mails and so on, then you might not truly have the time to be successful in your business. Occasionally we have given heartfelt advice to our photographer clients that their timing might not be perfect for launching their business. We would rather see the photographer wait a year or two until their children are at in school full time, their spouse received the promotion, or they are no longer bound to a personal commitment that would impact their availability to work on their business. Truth be told, it is extremely difficult to make a living in photography when you are fully focused on your marketing, sales, photography, and profitability. A major distraction to any of these pillars could mean a less than profitable business or worse yet, killing your love of photography. As you read this book, please consider if the timing is right for you. If you get excited about some of the ideas in this book, and can't wait to implement them, then you will likely run with this

information and create a solid business. If it seems too daunting to accomplish, then simply start piecing together the ideas in this book so you will be well prepared when you are ready to go full time.

4 | What Do You Need to Earn?

It may seem strange to ask the question: How much money do you need to earn? However, we believe when tackling the price list and session fees, it is best to approach this armed with valuable information gathered by the use of reverse engineering. We believe you must start with the end goal in mind. This is done by answering the following questions.

How Much Income

How much income do you need personally to make a living? If you do not have a home budget made, this is the time to create one. You need to know how much money you require to pay yourself to cover your household bills and provide the lifestyle you are accustomed to. Perhaps you are not looking for full-time income. You may be looking to earn additional income for retirement, to fund private education, or for other reasons. It is still important in these cases to have a specific goal, a specific number in mind before you arbitrarily throw numbers around.

Determine Cost of Doing Business

What is your cost of doing business? Cost of doing business (CODB) is the amount of expense incurred to keep a business open regardless of whether there are any sales on any particular day. This includes rent, electricity, internet, and other recurring costs. We cover CODB in depth in chapter 6.

Determine Cost of Goods Sold

What are your cost of goods sold? Cost of goods sold (COGS) are the direct costs associated when a prospect becomes a client. We cover COGS in depth in chapter 5.

Too often we work as hard as we can and try to make the most money possible without identifying these end goals. This is a very dangerous way to approach a business. If we do not pre-determine how much money we need to cover our product costs, cost of doing business, and money we need to live, we risk never paying ourselves a salary.

We believe you must start with the end goal in mind.

5 | Cost of Goods Sold (COGS)

Your cost of goods sold (COGS) is a number that will guide your business towards profitability and help you to price your products in a purposeful way. Before you determine what your prices should be set at, you should factor in your COGS. To do this, you must reverse engineer all of the expenses that go into delivering a product. These expenses are only incurred once a prospect becomes a client, and are not usually reoccurring each month whether you have sales or not. Those types of expenses are called cost of doing business (CODB) and those are discussed in chapter 6.

Many photographers believe that COGS are only the hard costs associated with producing prints for clients. This is incorrect. COGS include the cost of the print, your time to shoot the session, download and backup, retouching, creating presentations, the sales session, the ordering and unpacking of prints, the presentation boxes for the prints, framing and time spent framing, and interactions with the clients and staff about the order, the archiving of the files after the order is complete, and client follow up. Wow! A lot more is invested than just the cost of the print. Your time is far more valuable and should be factored in when determining your pricing.

In a perfect world, each photographer would determine the price of their art by what the market can bear. You would factor in rar-ity, quality, perceived value, and your region's demographics to determine value. This is an extremely difficult way to value an item, so we suggest you follow a set of guidelines to help get you close. You might not be priced high enough for your area, but we can develop some general minimums from studios that are profitable to get you started.

Our goal is to have our COGS percent end up at twenty-five percent or less against our yearly sales. Wait! That means we're making seventy-five percent profit? Nope, not even close. Remember those pesky CODB numbers we talked about in chapter 4 (more on CODB in chapter 6)? Those have to be considered as well. Let's try to keep things at or below twenty-five percent if possible okay?

With that goal in mind, you can roughly mark up your COGS about four or more times to determine your pricing. Keep in mind that it is very easy to think of a small print as costing very little and to just multiply it by four. This is incorrect, and we beg you to avoid that! Look at all the time that is involved with your session and other parts of your workflow, and then determine an hourly rate which you need to pay yourself, or pay someone else to do those tasks. Then determine how much time and how much money it would cost to produce if you have to pay someone else. Then you might multiply by four more.

6 | Cost of Doing Business

Figuring a correct cost of doing business (CODB) is a painful exercise. Do not attempt to do this without some form of libation and a good sense of humor, as you will think it is crazy to even consider running a business when you add up all of your expenses related to your passion.

CODB is defined as the costs associated with running your business even if you have zero clients. See what I mean? It's painful right? Just the thought of having to pay for everything without any clients is almost too much to bear. These costs include all of your overhead. Here is a partial list of expenses that are part of your CODB: Mortgage or rent, property taxes, utilities, employees,insurance, health insurance, travel expenses, maintenance, internet, studio snacks and groceries for clients, camera equipment, web hosting, marketing, postage, cell phone, computers, software, bookkeeper, lawyer fees, and more.

All of these items need to be either paid for from a different business, for example health care if your spouse is eligible; be brought into the company prior to its founding, for example camera gear, computers, software, and other assets; or become part of your CODB. If some of the expenses are covered elsewhere, please, we beg you, do not count on those expenses to be covered forever. There may come a time when your spouse changes jobs and health care is not covered. Figure your CODB with real numbers—numbers that would be reasonable to expect and that you may incur at some point in your career. By knowing these numbers you will probably work harder to market your business, as these expenses need to be paid even if you have no business.

As you determine you total CODB, consider ways in which you can reduce your total expense to make it easier each month to stay in business. We are not talking about consolidating all of your credit card debt; we are talking about taking a careful look into your monthly expenses, finding redundancies and extras, and cutting or reducing those costs.

It is suggested that you keep your CODB percentage at or below 35 percent. When you add your cost of goods sold (COGS) target of twenty-five percent to your CODB target of 35 percent, you are left with approximately 40 percent of each sale. Sounds great right? Well—have you read the chapter on taxes?

7 | Profit Is Why Businesses Exist

Are you ready for a *truth bomb*? Businesses that continually do not make a profit are called hobbies. Hobbies are great! They allow us to take time doing things that we want to do, just for the sake of doing them. There is not usually an expectation of compensation with hobbies. If you have reached that point with your photography business, or you just don't think you can make money with it, then it is time to reassess what this is all about.

The business of photography is first and foremost a business. It is necessary to make a profit as soon as you can, if you would like to remain in the industry. I am sure there are some out there who rely heavily on a spouse's income and fringe benefits, but that cannot be very fulfilling as an artist. As people, we tend to want to stand alone in our business skills whenever possible. How do we achieve that? Profit.

Unless we charge a significantly higher fee for the items we sell than it costs us to produce, we will soon be out of business. If you read the chapters on cost of goods sold (COGS), cost of doing business (CODB), and taxes (chapter 17) you are probably already aware that the cost of the print, is the least of your worries. You will need to fight the feeling that so many unsuccessful photographers end up feeling when developing their price menu—that they want to charge a "reasonable" price and

The business of photography is first and foremost a business.

don't want to "rip" people off. This flawed thinking focuses only on the hard cost from the photographic print and ignores all the larger costs. For example, "Since my 5x7s only cost me a little bit, I should be able to sell for twice what it cost me, and I make fair profit."

We see this attitude much of the time in online forums. It generally is a precursor to leaving the industry. These photographers can't make enough to survive, and they endure guilt from themselves or their family for charging enough to do so. This faulty attitude has to stop. Profit is not a bad thing. We all need to make profit to survive. We tell our clients that we have to make a profit if they would like us to be in business next year. They all understand because they all need to make a profit as well. We approach this as a service to our family and our clients alike. You should too.

8 | Packages

Packages and bundles have become very popular across many industries over the last thirty years. The lure of a lower purchase price, inclusive of all the products that a consumer might want, is undeniable. In the world of cable television and internet service bundles are catch phrases that resonates all over the country. In the world of fast food, "You want fries with that?" has been replaced with "Would you like to make that a value meal?"

Wedding photographers have been creating collections that essentially bundle all of the base items a couple might want from their photographer. These items might include a finished album, proof book, parent albums, and prints for each parent, wall portrait for themselves, and thank-you cards. By bundling these items together versus a higher cost a la carte price list, the package will save the consumer money over purchasing each item on its own. For couples, this eliminates their fear that further investment might be required after their event.

For portrait photographers, packages can enhance the perceived value of an investment point, and reduce their enmity to selling. Once a client commits to a package, the effort can be focused on fulfilling the items in the bundle instead of continuing to ask the client for a larger sale. Another benefit for the studio is in budgeting. If a studio offers collections that start at $595, then they are likely to know ahead of time that their minimum purchase will be $595. Using packages, you can guide your clients to your middle packages, which by design should be your most profitable. Once you estab-

lish a way in which your collections work, don't forget to offer a big collection— one that leads in a natural progression from your most expensive collection to your least expensive, but one that you do not expect most clients to invest in. The jump from a middle package to a large package needs to be a reasonable move. You cannot have a $1500 collection, followed by a $5600 collection. It is just too big of a difference. Once people are buying this larger package, make sure to add another package selection priced above it.

A few things to be careful about when creating packages. You run the risk that you have misread what your clients would like in a package. You can, by accident fill the package with items that the client is not inter-

ested in, reducing the value of the collection in the client's mind. They may say, "I know that this package comes with five 8x10-inch prints, but I don't want any, and you don't have a package with less than five 8x10s."

It also takes a fair amount of selling prior to the sales session to educate the client on how your collections might work. Even when well educated, packages can seem confusing. It is also possible to undersell the client's desire with collections.

If collections seem to make sense to you, consider creating a grouping of collections, and offer to add items from an à la carte menu to build up to the product level where they want to be.

9 | À La Carte Pricing

À la Carte is a French phrase that essentially means individual pricing. This pricing method has been around and popular since commerce was created. It is the simplest system for exchanging goods for currency. An item costs $1, and that's what you pay. Some clients love à la carte pricing as they only pay for exactly what they want. They do not want to bundle products together as they can feel that a bundle is another way to get a consumer to spend more than they had anticipated.

This method offers a variety of benefits to you and the consumer. It offers great flexibility for the client to be precise in their buying decisions. A client wants to purchase a 40x60-inch print and six 5x7-inch prints? They can do that, and it is unlikely you have a collection that includes just those seven prints. It allows the client to continue to add products on to your sale and reach a potentially higher sale, while giving your client a lower investment point if their needs are few. It is easier to sell since each moment spent in

the sales session is focused on the product at hand. It can be easier to achieve a commitment from the consumer since the cost per piece is smaller than a package.

You are never really done with the sale until the clients tells you they are done.

À la carte pricing has fallen out of favor with many industries, and photography is certainly one of them. Consumers like the value of bundles. Photographers who do not enjoy the sales process tend not to like ala cart pricing as it requires a fair amount of selling and attention to complete the sale. You are never really done with the sale until the clients tell you they are done. It can be more risky as a client may choose to purchase a smaller total amount of product. It can also be harder to implement in certain market segments of the photographic industry. Weddings and senior portraits are two areas of specialization in which the general public has become conditioned to expect a collection pricing menu in our market. Our studio uses this exact model. We are à la carte, but have a variety of collections in some of our product lines.

10 | Pricing of Wall Portraits

Can we all agree that we are in the business of helping our clients love their portraits? Wall portraits are the quickest way to achieve this. While albums and gift prints can be cherished pieces of art, wall portraits are the catalyst that provide our clients with passive enjoyment every day.

Wall Portraits versus Albums

Wall portraits are enjoyed when walking by, sitting and visiting with friends, or actively engaged in viewing. Albums, although they serve a great purpose, must be picked up and opened to be enjoyed. Gift prints must be enjoyed from a close proximity. Prints that are 8x10 inches and 5x7 inches are not well suited to be hung on a wall. They are best viewed when sitting at a desk. Wall portraits make a statement and become beautiful pieces of art in our client's home that can be enjoyed on a daily basis.

Our studio offers three wall portrait categories including a classic print, a canvas print, and a modern print, which includes a metal and gallery wrap. We realized some time ago that we prefer canvas prints as the look best suits our photography. In addition we live in New England where a traditional style colonial or cape style homes are common. Canvas prints typically are best suited to this style home. Metal prints have a more modern look and can be very popular with the right style home and the right style imagery.

Determine Your Products

When approaching our wall portrait pricing, we decided to utilize the good, better, best scenario described in the following chapter. We determined which products we wanted to sell—classic print, canvas print, and modern print. We determined which we wanted to sell most (the canvas print) and listed them in our price book in this order. We determined what price we need to charge for our wall portraits to be profitable. We realized that preparing a wall portrait print for a classic finish, a canvas finish or modern is exactly the same process. We decided to charge for canvas or gallery wrap as an upgrade fee as opposed to charging based on cost of print.

Pricing

We also priced our wall prints by the short side of the print. We sell 16-, 20-, 24-, 30- and 40-inch prints. All 16-inch prints are the same price regardless of whether they are 16x16- or 16x24-inch prints. We learned that our clients sometimes get overwhelmed with deciding on exact sizes. We found

it best to crop our client's images in our presentation software to a point that is most pleasing and let the size ratio fall where it may. This avoids clients trying to squeeze their family into a traditional 16x20-inch print when compositionally, their images calls for a 4x6 or a 16x24 ratio.

11 | Pricing: Good, Better, Best

One of the biggest more profitable changes we made since we opened our studio was moving to a *good*, *better*, *best* pricing structure for wall portraits. Prior to our change, we had looked at our cost of goods sold (COGS) in a way that left our canvas wall portraits very expensive and unappealing to our clients. We really wanted to sell canvas wall portraits. The look matches our photographic style, they were much easier to frame, and very few in our market were offering them. Our trouble was the jump from a traditional print to a canvas print was at least twice as much. It was too far a chasm to cross for many of our clients.

Our change came when we were sitting in a tire shop. While waiting for our car to be finished the phone rang at the shop many times. Presumably the customers were asking about tires and each time they called the mechanic literally asked the client, "do you want good, better or best?" In every case the caller on the phone chose the *better* tire. The mechanic ordered the tire, and the call was done.

This planted a seed in our head about something we had heard over the years from speakers on sales about the power of the middle product line. We chose to take a hard look at our wall portrait pricing and see if there was a way to make our canvas wall portraits more affordable. We decided to institute a good, better, best system. In our system, we made our traditional matted prints our *good* category, our canvas prints mounted to Masonite our *better* category, and our gallery wraps our *best* category. When we analyzed our COGS for each product we took a new approach to figure things out. All of the time we spend enhancing an image, the retouching, the presentation box, and post-production all fall under our COGS. These expenses are the same for all of our wall portrait finishes. The only real difference is the surface, presentation, and the associated cost of that presentation. We started looking at the change in presentation cost as an add-on above the cost of our traditional prints. Initially we believed if our traditional print cost was $30 and our canvas on Masonite costs was $60, then it would stand to reason that the proper price should be twice as much. We were wrong. We decided that the cost difference could be better viewed as an upgrade. The base cost of our traditional print and the COGS associated with it fell into line. Canvas costs us $30 more, so anything we charged over $30 was pure profit. We viewed it like the client had chosen a spray and suddenly our canvas were only about twenty-five percent more than our traditional prints. Now, our clients, who prefer the look, could now make the jump to the product we really wanted to sell—the canvas wall portrait.

12 | Gift Portrait Pricing

Most studios will sell far more gift prints than any other products during their career. It is the mainstay of what our clients are giving as gifts to friends and family members. Following the inspiration behind the *good*, *better*, and *best* pricing model can be challenging within the realm of gift portraits. We consider gift portraits to be 4x6-, 5x7-, 8x10-, and 11-inch prints. With gift prints, although there can be several finishes available, clients do not tend to invest in different finish types. They tend to order traditional prints that they intend to frame themselves.

> *When developing your gift print price list, make sure you have clear vision of your overall pricing menu.*

The cost from many printers tends to clump fairly close together. Many studio owners have suggested that since the cost is similar, the overall cost should not fluctuate much. An example would be prints that fall under proof sizes. 4x6- and 5x7-inch prints costs essentially the same from the printer, and require the same amount of artwork and image sizing. If this is the case, then they should cost the same on your menu. Looking at a traditional percentage markup based on your cost of goods sold (COGS) can easily lead to underpricing of these items. You do need to know what your COGS are for these products, but it makes more sense to create a pricing pattern that reflects a sensible overall scale. Your mark up, when compared to the print cost might be twenty to forty times your out of pocket expense on the print. Remember that each of the prints you sell, need boxes or portrait cases. The boxes cost more than the print, and your time costs more than both of those hard costs combined. That needs to be accounted for when you are developing your overall menu.

All of our prints are sold as individual portraits with the exception of wallets, which are sold in multiples of eight. We do not use the *sheet* terminology. We individually retouch each file and order individual gift prints to match the clients order. When developing your gift print price list, make sure you have a clear vision of your overall pricing menu. Be watchful of large jumps in pricing that would create an emotional barrier for your client.

| **Album Pricing**

Album sales are a bit of a conundrum. As businesspeople, we want to sell the larger ticket items as it makes us feel good about our session sales. Some products like albums have a high cost to produce, making it difficult to remain profitable.

When pricing albums for product lines, many photographers look only at the hard cost of the album. Let's say, an album costs $120 from your vendor. Many photographers simply multiply their hard cost by a factor and arrive at a price. This method could work if the factor was high enough, but lack of confidence across the industry in pricing leaves many photographers wary of pricing the albums correctly.

ALBUM PRODUCTION TIME AND COST	
Collection of imagery and retouching of twenty images:	1.3 hours ($30/hour) =$39
Layout, design, and approval of album:	2 hours ($30/hour) =$60
Ordering and unpacking of album:	3 hour ($30/ hour) =$9
Packaging :	$10
Total time investment:	$118
Album hard cost:	$120
Total cost:	$238

There is a simple factor missing from most studios album's pricing. They are overlooking the amount of time that it takes to produce an album. Some think it is not hard to build an album. Let's take a look at the time and cost that would be associated with production of a high school senior's album if you were not able to work for free. In the above chart, can you see now how just doubling your hard cost of an album might be leaving zero profit on the table for you the business owner? We are not telling you what to charge for an album, we just want you to see how much time, effort, and money is put into a product, and to price the product accordingly.

A breakdown of wedding album production time and costs would be far more expensive. Although working on images can be rewarding, imagine if you were not able to do the work, and you had to hire someone to produce it for you. This is a great way to determine your total costs.

A Choice of Session Fees

When figuring out your cost of goods sold (COGS), the easiest way to get your print prices down is to get some of your time paid for in the beginning. Session fees allow photographers to get paid up front for their time and talent. It also can tell your community what value you place on your time. In many cases, our culture places a higher degree of value on items or services that cost more. By setting yourself up with a session fee, you are sending a message to everyone that you are good at what you do, and you should be compensated for your time.

We have several different session fees based on the amount of time required. We have different pricing for each of these session types:

- Senior indoor or outdoor or both
- Children or family indoor or outdoor
- Extended family session
- Session on location (within thirty minutes)
- Beach session (three or more families)

Fee Arrangements

Charging a session fee up front has a tremendous effect on your pricing and COGS as it pays for much of the time that goes into making your first images from a session. Some studios have found success with charging a larger session fee with part of the fee being a credit towards a collection purchase. Others have chosen to charge an even larger fee, but with all of it going towards a collection purchase. A studio we know offers their collections as a pre-buy at the pre-session consultation. They offer a discount to purchase a collection prior to the session and the studio rewards their guaranteed sale with a 20 percent discount. The adage that "money spent is money forgotten" probably plays a big role in the success of this method of pre-buy.

Our studio policy is to collect the session fee at the time of booking, whether it is over the phone or in person. We have found that sessions booked that were not prepaid, had a high no-show percentage. Conversely, in fourteen years, we have not had more than one no-show on a prepaid session. Translation: Our time is valuable, and you need to prepay to reserve it. We just could not maintain our studio if our clients did not show for a multitude of sessions.

If you fail to plan, you plan to fail. We have found this adage to be true in the portrait industry. A simple yet effective way to achieve exactly what your client is looking for is simply to know what they want. The best way to know their wants and needs is to ask. When do you do this? At the pre-session consultation!

Whether this is for a newborn session, commercial session, or event photography, discussing the ideas and details about the session will help make everything go smoother. You are also more likely to have a client who leaves you completely satisfied.

Although not every client is available to take advantage of this meeting, we encourage our clients to schedule a short visit to the studio to chat about their upcoming session. We ask them a series of questions to help us to focus in on things that are a concern to the client.

Who will be photographed? When would you like to do this? Why now? How did you hear about us? How were you thinking of using the imagery? What are the nursery/home colors? Tell me about your family. What are you favorite things to do? What is the one thing we need to know about your family?

These questions are all about getting our clients to begin to feel comfortable with us. This is the time to ask the question, and then allow the client to speak. It is not about getting through all the questions. It simply is an opportunity to connect with the client prior to the stressful moment when they walk in the door with three children, none of whom wants to be there! Keep in mind that the person who can make this appointment is also likely the person who is most interested in this session and is tasked with coordinating the session.

During this meeting we also chat about clothing. We would love to know the colors in their home, and which colors they envision their portraits to include. We coach our clients about what helps to make successful portraiture. We have found that darker, solid colors tend to allow the eye to rest on the faces of our clients. We do not encourage them all to wear the same top in different sizes. We want them to have a sense of personal style maintained throughout their portrait. The eye travels first to the highest point of contrast, and given a choice, we want that to be the face. We also would prefer clients wear all the same value pant or skirt. Again, not the same item of clothing, but the same value. If you squint your eyes, and look at the clothing laid out before you, you will notice if a particular piece stands out. If one piece does, then replace it with one that does not. The main focus of our portraits is the face. All of the clothing choices should support that goal. Nothing sinks a portrait session's impact than a red shirt in a sea of white shirts.

Taking the time for a pre-session consultation will not guarantee success, but it certainly will remove many of the obstacles to failure.

Price List Psychology

A lot has been written about price list psychology. The first rule about price list psychology is we don't call it a price list. We call our collection of products and their corresponding prices a product guide or product menu. We never talk about price. Price is a word that makes people cringe, and much of the research about price menus concludes that removing painful words and math will make for a more pleasing menu and hopefully for a more profitable studio and happier client.

It is all in the numbers. Some cultures like certain numbers and consider them to be lucky. We are not suggesting that you choose numbers based on luck, just keep in mind that certain numbers in certain cultures can denote more than you might want them to.

Generally we like to end our numbers in fives. The number nine, although it helps to give the perception of a good value, can come across as being very retail and somewhat misleading. When we present investments in our menu, we remove all of the dollar signs associated with our products. Taking the cue from high end restaurants, we simply use a dash to illustrate a product's cost. For instance, instead of $395 we use ~395. The numbers do not change, but consumers have a negative emotional reaction to the dollar sign. This might sound like we are playing games with our menu, but in fact we are just following the lead of those who have done the research before.

Consider listing prices most expensive to least expensive. This allows any shock that is felt by the client to settle downward as they see smaller prices than their first initial impression.

Keep It Clean

Images of other families or children are distractions that draw their eye away from the business at hand, ordering their portraits. Your price font size should be smaller in general. Consider what type of business you are. Are you a high volume studio? Low-volume boutique studio? Your font

choice, size and graphics might be very different. A school photographer might use an exploding star with a large font choice to draw attention to the package that is most profitable. In a boutique studio this would probably work against all of your efforts to brand a high-end business model

Keep It Simple

You don't need to have a product listing for everything you offer as long as you can determine a price when the client asks about it. It is not desirable for a client to have to wade through endless pages of items to find the one thing they are looking for. There are a few national restaurants, whose menus are so extensive they sell advertisements in-side the menu to break up the food descriptions. Don't choose this option.

When speaking about your price list consider pointing to the menu item and allow the client to say the price in their own head. We as an industry tend to say a price and then fall over ourselves to justify the client's investment. By letting the client say the price in their own head, they are determining whether it is in their budget or not, or how they intend to pay for it.

When it comes to price menus, we are not trying to play games, but instead we are trying to make it easier for the client to do business with us. Keeping it simple and streamlined seems to be the best approach.

17 | **Taxes**

Show of hands—who read this chapter first? I bet collectively the answer is zero. Taxes are one of those subjects that no one wants to even think about. Before you read any further, the opinions expressed in this chapter are just that—opinions. They are not from an accountant, tax lawyer, or IRS employee. They are just from a fellow entrepreneur who has paid a lot in taxes and has had to develop methods to collect the capital to pay them on time.

Okay—let get right to it. You have to pay taxes. If you make a profit, it is your legal and moral responsibility to pay your share as prescribed by the current tax code. No one wants to pay taxes, but we do love driving on pavement, having a national defense, and visiting Yellowstone National Park every couple of years or so.

In your first year in business, you are not likely to make any profit. The startup costs of businesses are high, and sometimes it takes several years to break out the black ink. You are not likely to have to pay a lot in taxes until you start making a profit. On your first profitable year, you will be expected to pay your entire tax bill from the previous year when you file. Don't say we didn't warn you. It can be quite a surprise, and it can be and often is a lot of money. Don't let April 15th come around and find out that you owe $17,000 but have nothing saved for it.

Save for Taxes

We encourage you to start saving for taxes even before you make a serious profit. In fact, we *beg* you to do so! If you start putting away approximately 20–30 percent of your expected profit from each order, you should find yourself with a good size amount of money in the bank with which to write that check on April 15th. Many photographers have brought their studios to a point of profitability only to go out of business due to their unforeseen tax liability. We are warning you right now—don't let this happen to you! Successful business owners have good fiscal discipline. If you lack the discipline, find a technique to improve it right away.

Your First Profitable Year

Once you get your first profit- able year under your belt, your hard work is rewarded with a gift called quarterlies. Once profit- able, you are expected to make a quarterly tax payment four times a year. This will definitely help with the sting of April 15th as it spreads your payments into smaller payments throughout the year. It is important to make the payments on time as there can be fines for late payments. There are a lot of ways to ruin your busi- ness, but not paying your taxes is the fastest, guaranteed way to make that happen.

Every State and County Is Different

As every state and county is different, it is important to speak with an accountant about what you will be liable for with sales and use taxes in your commu- nity. Some regions tax all sales, while others tax only when products are produced; for instance, it is taxable to provide a disc with images, but not taxable if you e-mail the files. Sound confusing? You are right! Please don't take advice from those who are not tax professionals and don't work in your region. Contact a tax lawyer or CPA, and make sure you are compliant and up to speed with local sales and use taxes.

Get Licensed, Tax Identities, and Pay Taxes

Get ready for a stern lecture. If you are not collecting sales taxes, and other businesses are collecting them in your area—you are cheating. You are playing on an unfair play- ing field. If you want to be in business, act like a business. There are many incentives for your colleagues to turn you in for tax evasion in many states. Please, make sure you are properly licensed and are set up with the proper tax identities for your local commu- nity. Lastly, when you collect sales tax, please put it aside right away. It is not your money, so don't spend it! Remember, if you have to pay taxes, you are doing something right. Keep up the good work!

18 | Copyright and Model Releases

We are not lawyers, and therefore, this section is not legal advice. Model releases are a subject brought up by many people across the United States and abroad. First, we only have a small amount of experience with model releases in the United States, not in other countries. Each country has their own set of copyright laws and privacy laws. For this discussion, let's focus on the laws that affect photographers in the United States.

Copyright and Licensing Agreements

In the United States, once an image is created, it is copyrighted. Nothing more needs to happen. The action of pressing the shutter is the action of copyrighting your image. This does not mean that you are all clear and shouldn't think more about it. Copyright registration of images is highly encouraged, and there are books that cover that very topic. We mention copyright here just so you don't give it away. The only reason to give away copyright is to deny the maker the use of their art. If you choose to give or sell clients your files, you might consider using a licensing agreement, one that spells out exactly which images are included, the terms of the license, and the manner in which the client can reproduce the imagery. Many times, model releases and copyright get confused.

Model Releases

Model releases give the photographer specific rights to use a subject's likeness or their children's likeness in a variety of ways such as advertisements, books, websites, stock photography, and so on. Every state is different, so we encourage you to have a short chat with an intellectual property attorney, or do the research yourself to determine what your exposure will be in your state.

Most of our client images would not be suited to selling for stock or advertisements. We produce classically lit professional portrait photography. Today's market of stock photography generally looks to lifestyle photography to fulfill its needs. These two styles are not even close in nature, so we focus on the model release as a courtesy to our clients in case they do not want to have their images in the public eye for a variety of reasons.

Some states specifically allow the photographer to use images they create of clients on brochures and websites without a release, while others hint at being able to do that. Some other states legislate that a model release is required to promote the photographer while other states focus their concerns on commercial gain.

Obtain Release before Photographing

What is our point in all of this? You have to find out where your state sits in terms of model releases, but do not wait until you have a problem. We obtain a release from each client when they fill out their welcome paperwork, and they sign another when they complete their order. We do this not because we are expecting problems. On the contrary, we have never had problems because we take these steps and respect the client. We have our discussions before the client has been photographed, not after. This way we can address any concerns with the client right away. In many cases you will not have a problem with releases, but it never hurts to have one in your hand should something go awry.

| **Retouching**

Our general rule of thumb for retouching is we want to go back about five years. We always joke, "If you don't like your portrait today, give it five years!" Clients laugh, but it is pretty much true. We as a culture look back about five years, and think we looked pretty good then. The

We then add a layer of skin softener to just the face. . .

trouble is five years ago; we didn't think so at the time. We really have to be easier on ourselves when it comes to portraits. We are so used to seeing our faces in the mirror that when confronted with a true positive of ourselves, it seems alien. Let's say our right earlobe is larger than our left earlobe. In the mirror, our just barely larger right earlobe is on the right side. In portraits, the earlobe that doesn't bother us at all in the mirror is now the size of a zucchini as it is on the left side of the portrait. Everyone in the world except you sees it correctly, but you see it wrong. Maybe we are not good at choosing our own portraits?

When retouching we do not want to take away any of the character that a subject has earned in their face. We like to leave some lines and wrinkles. We do tend to tone down some of the lines created by our three dimensional lighting patterns. For instance the lines or bags under the eyes of our subjects are caused by light coming across the face. It is our fault that those lines show up. For that reason, we tend to lessen them quite a bit. We then add a layer of skin softener to just the face, and erase the softener off of the hair. We use Imagenomic's Portraiture® plugin for skin smoothing.

Most of the year we do all of the retouching in house, but on some occasions we outsource it to a vendor. It is a way of having temporary staff without all of the training, parking, or employment hassles. For this we use the online service Retouchup.com to handle our overflow.

Since the level of retouching is a bit of a personal style and taste, we do not overwrite any of our original files when retouching. This way our originals are available if the client would like us to revert to the original. For our ease, we simply save them as a new file with the letter *r* at the end of the file extension. These files can easily be found in a folder by arranging by the date it was modified.

20 | Packaging

When choosing packaging for finished portraits, form, function, and design should be considered. Imagine opening up a box from Tiffany and Co. The anticipation rises as you see the signature blue box with white ribbon. Just by seeing the box, you know something great is awaiting you inside. We want to create this same sense of anticipation for our clients. We want our clients to feel like they are opening a gift when they receive their portraits. For this reason we beautifully package our products for our clients.

We prefer to have our clients open their portraits in front of us.

We purchase our photo packaging supplies from H-B Packaging and Rice Studio Supply. We order our bags and tissue paper from Nashville Wraps. All of these companies offer a variety of products, sizes, and finishes to create beautiful packaging that will suit your individual style. We order boxes in many different sizes with tissue paper to ensure the portraits are secure during travel. Each box has a name tag affixed for our ease of identification that we remove prior to handing the portraits to the client.

We prefer to have our clients open their portraits in front of us. This is a form of quality control. We can gauge from their expression and reaction if our job is complete. On

occasion this method has caught a small error on our part. We have realized that a print was missing, or a quantity was incorrect. This is the perfect time to correct the situation. We also present our framed portraits wrapped with protective frame corners. This allows the client to enjoy the final product while protecting the artwork during the trip home.

21 | Workflow

Our studio works both on location, outside at our studio, and in studio. We produce photography for a wide variety of commercial clients and commissioned portraits. A consistent workflow helps us to produce consistent imagery for all types of clients under various working conditions. Creating a workflow that takes your style and thought process into account is very important. We have a fairly simple workflow. Let's take a look at our process from capture to back up.

Capture

We photograph all of our sessions on RAW and JPG settings. We do this for several reasons. If we have a card go bad, which has only happened a few times in our career, a JPG seems be easier to recover than a RAW file. If tragedy strikes, we are as prepared as we can be. We shoot this way so we can view a complete JPG without having to process a RAW file right after capture.

Copy, Save, and Cull

We complete our session and insert our card into our onboard card reader. We open our folder and view the files by type. First, we copy and paste the JPGs into our client folder. Once this is complete, we copy and paste the RAW files into our client folder. If the client is viewing their portraits immediately after their session, then we start the culling process right away. We use the Windows photo-viewer utility by double clicking on a thumbnail. That expands the photo to full screen and allows us to scroll through the JPGs in numerical order by using the left and right arrow keys. Images we keep, we hit the right arrow key to advance to the next image and images we do not want to keep, we hit delete and then confirm the deletion by hitting enter. We are removing extra poses, blinks, poor exposures, test images, and so on. If we make a mistake and delete the wrong file, we can always access the JPG from the card. We do this as the RAW files download, so we save our clients time. Usually by the time we are done culling the images, we are done downloading the RAW files. One key point to mention—we get our image files right, to the best of our ability, at the time of exposure. This means within a third of a stop in exposure, and 200–300 degrees in Kelvin with regard to white balance. If you are not producing JPGs at that level, then we encourage you to buckle down and get it right. We do not process files that the clients do not purchase. There is no profit in processing images that will ultimately be deleted.

Album, Sale, and Thumbnails in Receipt

After we have our set of straight-out-of-the-camera (SOOC) JPGs, we make an album

using ProSelect software by TimeExposure. We use ProSelect to present our images to our clients and aid them in their purchasing decisions. After the sales process, we print a receipt with their order and include thumbnails on the receipt to keep their excitement high until the delivery of their portraits.

Files: Process, Retouch, Back Up, and Delete

We then process only the RAW files of the images that the client has ordered. We enhance color, refine white balance, and sharpen for printing. We then either outsource our retouching to a vendor, or work on the images in Adobe Photoshop. Either way, we crop the images, place in the proper folders, and upload to our printer, White House Custom Colour, Inc at WHCC.com. After the upload is complete, we delete all of the RAW files that do not correspond to our original set of SOOC JPGs. We do not delete all of the images that were not ordered yet, just all the RAW files that do not have JPGs associated with them from our original cull. We then back up to our server, and a portable hard drive device that travels with us to and from the studio. After about a month with no new activity, we delete all of the files that were not ordered, keeping any files that we personally like for a portfolio builder. This method is very effective at keeping us on task and maintaining a workable archive of our client's files for the future.

| # Time Management

Balance is a tricky thing to accomplish when working in the portrait business. We all tend to love what we do, so it is very easy to let tasks that should be mentally assigned to the business to creep into personal tasks that you don't count towards your business. Here are a few we can think of in our world that we tend to attribute elsewhere, time wise: deposits, Facebook for business, business e-mails, packing gear for jobs, cleaning the studio, and so on. All of these activities really fall under different cost centers, for example, cost of doing business (CODB), marketing, or cost of goods sold (COGS). At no point should any of these be considered personal.

Time allocation becomes an issue for our industry. We seem happy to work from home designing wedding albums, culling sessions, answering e-mails, developing marketing pieces, and so on. All of this activity cuts into our ability to be "off work" when we are home. It tends to impact those who have been very supportive of our career choices. Family and personal life tends to suffer for our art.

Here are a few ideas to help manage your time and become more efficient.

Live By A Schedule

We have always loved the phrase "All things in moderation, including moderation." We have found this to be true with our schedule as well. We are tightly scheduled, but we do allow for fun things like lunch with a friend, or each other, attending daytime events at school for our children, or even taking a full day off to go and photograph landscape images. Schedule your business e-mail activity to only a few times during the day, and this will help it from encroaching into your non-work moments.

Create Lists

Start and end every day on your list. Before you leave, write down the things that need to be done in the morning. Upon arrival add the items you thought of or came up over the course of the evening. There are many apps on the market that allow for list creation. We work together in the studio, so we need to have a paper list that we can both access when a block of time opens for us. The simple act of crossing things off can give you a boost to go forward and attack the next project. Don't do the fun stuff first. Tackle the item that you don't want to do. This gives you a psychological advantage to feel good about taking on the hard task, and when complete, you have the fun task to look forward to. If you take on the easy stuff, the hard things are still weighing on you and you do not get the enjoyment for the activity that you could have.

Turn Off Distractions

Facebook, phones, staff. When you have to focus, focus. Social media, ringing phones, and staff questions can eat up several hours during the day. Don't kid yourself about multi-tasking. It is not an efficient method for most everyday situations. You cannot watch a movie, and edit a wedding at the same time. You will find yourself just watching the movie every once and a while. It is a time killer. We know this from experience!

Analyze Your Time

Are you getting better or worse? Have you left your desk in hours? Should you go for a walk? Can someone else do this? How much time did you spend on this task? Are you getting paid for it? There are hundreds of other questions you can be asking about your time management. Look at it closely.

Before starting though, we want to encourage you to do more than just get more time in your day. We ask you to find ways to also make your time more effective, not just more efficient.

23 | **Employees**

Hiring an employee might be one of the best moves a photographer can make to help grow their business. Success can happen quickly when two or more are working towards a goal and doubling the amount of hours that are available to work on a business.

Employees, however, tend to create a challenge to our industry. Personality, skillset, and experience are all traits that need to be considered before you invite someone into your business and give them access to your clientele. Currently, it is suggested that for every $100,000 in sales, a studio could use one employee. Keep in mind you are employee number one. If your sales fall below that mark, then you might not be ready to add a full-time staff member to your studio. You might benefit from additional part time help until your sales reach the point in which a second staff member makes sound financial sense.

Before Hiring

Before hiring someone, make sure you have the correct amount of capital needed to keep and pay the employee for the term you are anticipating. Have a clear vision of what your new staff member will be doing for you. Will they answer the phone, represent your brand, sell your sessions, handle your social media, take out the trash, and assist on sessions?

Before you hire your new employee, keep in mind there are a lot of hurdles to jump through before you will find yourself in compliance. Many of these steps need to be completed prior to hiring an employee. Here is a partial list of suggested steps necessary for your studio to be in compliance. Do not even consider paying someone under the table!

Steps for Hiring Employees

Follow these steps and research what is needed in your state before making the bold move of hiring a new staff member.

- Obtain an Employer ID number (EIN).
- Register with your local department of labor.
- Set up an account with a payroll service.
- Obtain workers compensation insurance.
- Obtain IRS form w-4 and I-9.

- Post your state's required announcements and notices in your workplace.
- Report your new employee to your state's labor department as a new hire.
- Adjust your workplace to comply with any and all OSHA guidelines.
- Create a policies and procedures' manual and an employee handbook.
- Start a personnel file for each new staff member. filed in a secure place.
- Determine what benefits are required to be offered.

We encourage studios to produce phone scripts for their day to day interaction with potential clients. We're not thinking about the boiler room phone scripts found in a timeshare sales office that you see in the movies or television. Think more along the lines of checklists. Checklists that make certain you cover all of the education you need to get into the minds of your clients. Many clients will ask questions about your services during your conversation. These questions can distract you from remembering the points you wanted to cover. This should be no issue. You can simply check off the questions the client has on your worksheet if they overlap.

You might create your phone scripts for the different type of sessions you offer. It will take some time, but some of the information will be similar across all of the session types you offer. You can keep all of these scripts on a clipboard by each phone for easy access. Let's take a look at one of our phone scripts. Many of these questions would be answered during the pre-session consultation, but some client's schedules prohibit an in-person meeting prior to the session, and they book on the phone without coming to the studio.

A Family Session Phone Script and Checklist

- How did you hear about us?
- Who is being photographed?
- In studio, outdoor or on location?
- Extended family?
- When is the last time you were photographed?
- Discuss clothing options.
- Schedule Premier.
- Discuss investment ranges and payment options.

- Confirm session date, time and place.
- Collect prepaid session fee with a credit card.
- Confirm session scheduling in studio software.
- Do they know where the studio is located?

Do you see how this is not really a phone script, but a map to make sure your client is well taken care of when the phone rings? Imagine how subtle changes could be implemented to cover different session types. For senior portraits, you might be asking about siblings, the high school they go to, and if the client is aware of the deadlines imposed by the school? Apply this basic outline to all the types of sessions. Your staff and clients will thank you for being so thorough, and they will feel your studio is organized and well prepared for their session.

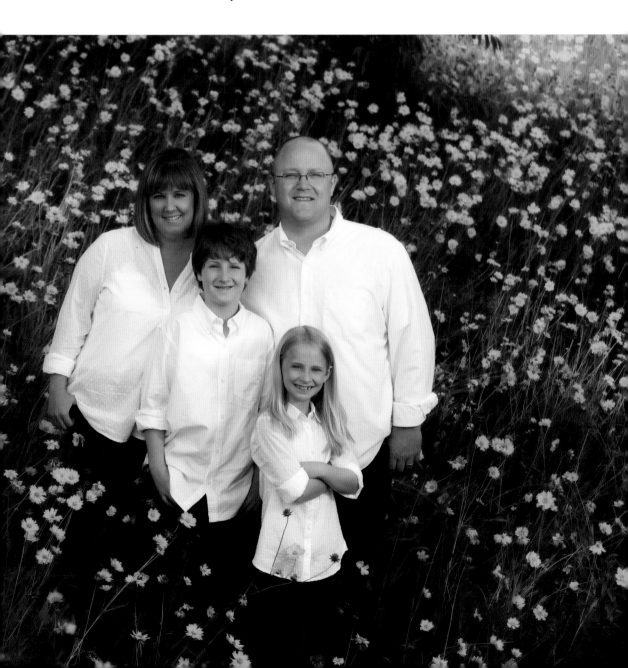

25 | Organization

Every studio should have systems in place to organize the workflow of scheduling sessions and fulfilling orders in a consistent and efficient way. We have developed a system that works well for our studio and has helped us keep on task and organized. Like many things in life, organization is an evolving process. We are happy with our current system but are always on the lookout for new ideas that can make our workflow even better.

Scheduling, Session Details, and Fee Collection

Let's begin by reviewing the workflow of scheduling a session. Once a client is ready to schedule their session and a date and time has been established, we then review a list of information to arm the client with knowledge and prepare them for their session. We review clothing options, investment information, directions to our studio or the portrait location, as well as get them thinking about their home and what their portrait needs might be. We also collect the session fee at the time of booking.

Files, Folders, Purchases, and Order Completion

After the session, the files are quickly edited, and a Proselect folder is created as discussed in the workflow chapter. After the premier or sales appointment, we print two copies of the order, one for the client and one for us.

Our copy goes in a folder to be entered into QuickBooks for accounting purposes. After it is entered into QuickBooks it is stamped entered, and then labels are generated for each box or framed print that will be delivered to the client using a Dymo label writer. The order and labels are placed in a plastic job ticket holder. From here the order goes to a bin titled "working orders." Each item on the order is check marked as it is completed. Once the enhancements are done on the files and the print and any framing orders are placed, the order form is stamped with a red star to indicate completion. A thank-you card is printed from one of the chosen images and mailed to the client.

Bin System

From here the order and job ticket holder is placed in a wall bin in the production area of the studio. We have a wall bin system with five bins labeled as follows.

- Incomplete- this is for orders that are awaiting prints or other items such as albums or folios. As items arrive, they are highlighted and placed in beautiful packaging.

- To be framed: orders that are in but still need framing.

- To call- order is complete, the client needs to be notified and a pickup time must be scheduled.

- Called: client has been notified order is ready for pickup

- Follow up: client has picked up order, follow up is needed to ensure client is happy with order and all needs are met.

Like many things in life, organization is an evolving process.

As you can imagine the orders move through the bin system until complete. Once completed, the order form is placed in a file cabinet.

| # Identify Your Target Client

It is important to identify your target client for many reasons. The act of even trying to define a target client will help you narrow down who you are supposed

Use your findings to create a studio brand and marketing plan.

to work with and who to market to. Most photographers begin knowing that their target client is anyone who is willing to give them money for their photography. Over time, as we photograph more clients, we realize we are better suited to working with some than others. Success can be found in both high and low-volume studios. The key is to determine who you want to work with and develop your brand and business model to draw this type of client. Unless you know who your target client is, you will be unable to do any effective marketing.

To determine your target market you have to previsualize who your target client might be. In our market women are the most prominent buyers of photography. This does not mean that men do not appreciate photography, but rather that women are usually the initiators of purchasing photography. What does this mean to us? It means that we want our studio, marketing, and general overall image to appeal to women.

We encourage you to make a list of who is your perfect client? Ask yourself, where do they shop, where do they eat, what do they drive, where do they live, and what type of income brackets are they in? Use this information to determine who you want to work with, and then use your findings to create a studio brand and marketing plan to draw that target client in to your studio.

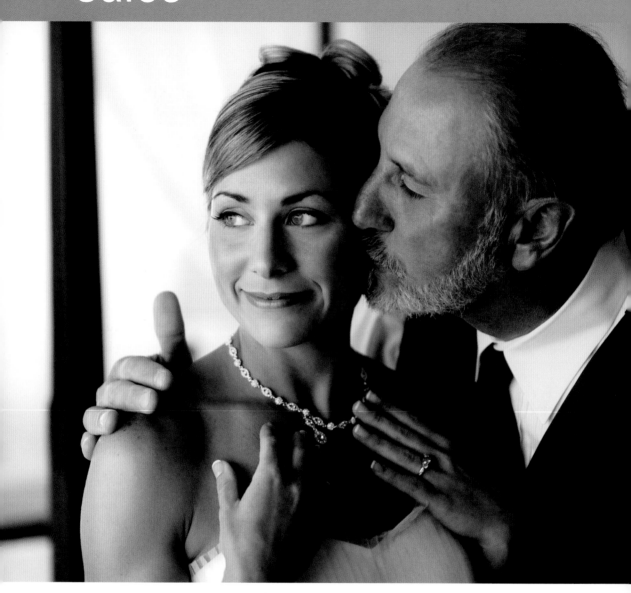

27 | **Client Perspective**

As business owners, we wear many hats. We must market our business, maintain our books, photograph our clients, sell our work, produce the finished products, and the list goes on. Periodically, we should try on a different hat, the

hat of consumer. Take time to analyze the process of scheduling a session. Was it an easy and informative process? Take time imagining you are the client being photographed at your studio. Was it enjoyable? Was the process cumbersome or relaxed and welcoming? Imagine being your client every step of the way from booking your session to parking your car, being photographed, using the changing room, making a purchase and picking up your order. It is important that you actually imagine that you are your ideal client. How was your experience? Here are a few questions you might ask yourself?

- Was the website easy to navigate? Was it easy to find your phone number on the website?

- Was it easy to schedule the session and did you get all the necessary information about your session at booking?

- Was the studio easy to find with good directions given?

- Was it easy to park and find the final destination?

- What was your first impression upon entering the studio? Did it smell nice? Was the studio messy or organized?

- Were those greeting you upon arrival welcoming, offering refreshments and leading you to a space to hang your outfits for changing?

- Was the process of being photographed enjoyable?

- How was the process of viewing and purchasing portraits? Was the price list easy to read and understand, or would you need the sales person to explain it all to you?

- How was the experience of picking up your finished portraits?

We encourage you to physically drive to your studio and walk through it with a fresh set of eyes, imagining yourself as the client. If you cannot be objective, then ask someone else to do this. You may be surprised at what you will find. Remember that a reaction is always more valuable than an opinion.

Our goal at our studio is to do this exercise at least once a year. When we are honest with ourselves, we find new ways to improve our client's experience. No matter what, there is always room for improvement. If you are working from a home studio or strictly on location, consider these same questions modified to suit your particular situation. Your studio will benefit, as will your clients.

In-Person Sales

Until recently, photographers only sold their work via in-person sales (IPS). IPS is a method in which the client receives all of the benefit of the artist's time and vision to help them come to a buying and decorating decision on how to use the portraits they commissioned.

With IPS, the photographer tends to take more time with the client to address the client's needs for the portraiture that has been created. Even during capture an IPS studio is more attuned to the clients as their total sale may depend on it.

Our Goal

Our job is not to sell the client on a high dollar item that will reap big profits. Our goal is to help the client get the images they want, and give suggestions on how to best display them in their home so their enjoyment is felt over many years. This involves an active dialogue between the salesperson and the client. Together they choose the best imagery from the session and discuss color or black & white; traditional, canvas, or wrap finishes; and cropping and proportional portrait design.

Covering Costs

IPS also involves offering a variety of sizes, finishes, and framing options. IPS generally allows the photographer a sufficient profit to maintain a business and cover

Our goal is to help the client get the images they want, and give suggestions on how to best display them in their home so their enjoyment is felt over many years.

their cost of goods sold (COGS), cost of doing business (CODB), and owner's compensation. We feel the client experiences the benefits of IPS the most. They gain the assistance and artistry of the salesperson and photographer.

Factoring Time

IPS does take a significantly longer amount of time to complete the order. A sales session is required. Retouching, print packaging, and more, all take the studio personnel's time and needs to be factored in during the process of developing your prices. In the end though, the client saves time and effort, and they will be happier with their selections from an in-person consultation. We strongly believe that this is the best way for our business and for the client.

Shoot-and-burn is a business model in which the artist makes the imagery for the client and turns over the images along with a license to print, or in some cases full copyright to the client. The photographer typically does not offer products for pur- chase to the client beyond the media that the images reside on.

Clients send their files, not professionally retouched or enhanced to an online printer to produce their prints or they print them at home. Tragically, many place their disc in a

drawer and never print them or enjoy them at all. Client satisfaction is not easily quantifiable as many clients to this business model never return. Left unprinted, their time becomes a waste, as no tangible memories exist beyond a DVD.

When we hand a disc or thumb drive to a client, we are telling them, that the entire burden is on them. They have to choose the right image, expressions, size, shape, and finish, and even to retouch and enhance the image themselves. It is much like a physician giving an x-ray, and telling the patient to go home and determine their own diagnosis.

Shoot-and-burn is the method in which many talented photographers start their business. Although we do not encourage the technique, as we have seen it consistently frustrate consumers and photographers alike, we understand that it might be appealing to many at first.

Our studio has been solely an in-person sales (IPS) studio since its inception. So you might understand if we take this opportunity to try to convince you that although easy to do, shoot-and-burn can end up leaving both the consumer and the photographer unhappy in the end.

Here are a couple of issues that we have seen with the shoot-and-burn model.

1. Clients do not print or even look at their images. Everyone's efforts have been poured forth, and nothing of value to show for it.

2. Very few referrals are produced from clients who only receive a disc—except for others who only want a disc that will be rarely used.

3. Complete loss of control as to how your images look in the final production of your vision.

4. High degree of probability that future generations will not be able to open the disc, or even find the media to access later. We are living in the most photographed generation in history, and the least preserved.

5. Files are for sharing; printing is for preservation. Cloud backup and inexpensive storage has led to a false sense of safety in the arena of archiving digital files. Hard drives are in two states: failed and about to fail. Cloud storage is risky at best. Prints on the other hand offer years of enjoyment, every day they are displayed. There is an old adage that people don't run into a burning house to save their hard drives, but they will do so to save their family portrait albums.

Whichever model makes sense to you, consider all of these points before making your decision.

It is probably clear that we are proponents of in-person sales (IPS). If you have come to the conclusion that IPS might work well for you, your bottom line, and your client's happiness, then some decisions have to be made. There are several different presentation options to help with your sales. In this section, we will discuss several different possibilities, and how they might be better suited for a photographer's particular situation or style.

Tablet/Laptop

Many photographers have found success with working with a client next to a laptop, or using a tablet to scroll through images. There are many apps that help the artist display their images so the client can easily choose their favorites and to visualize the finished pieces on the client's walls. This presentation is excellent as it allows the artist to be geographically close to the client which if handled correctly, can be a benefit to the client. They will likely feel more connected, and your words and opinion may carry more weight. Another benefit is the portability of either system. You could have your IPS session in a client's home, a coffee shop, or in your studio.

Potential drawbacks to using a tablet or laptop are the client can only see an image as large as the screen. 10- to 17-inch diagonal screens tend to have a lack of impact.

The image can generally be zoomed in, but the screens never get larger than a piece of paper.

Projection

Using a digital projector is a great way to illustrate the correct portrait size for their favorite images. A projector can project a 40x60-inch image or larger. Photographers tend to project their images into a framed movie screen or foam core. In many cases, a vertical 30x40-inch screen can be projected successfully. Proponents of projectors report that clients tend to purchase portraits one size smaller than their largest available projection size. This is an obvious advantage. Some projectors are portable enough to carry into a home and project imagery right onto a place reserved for their portraits.

Some concerns to address are not all projectors are created equal. Many do not offer enough contrast or are bright enough for a particular room. An inexpensive projector likely will mean that all the lights in the room will need to be turned off for proper viewing. This can reduce the impact of your sales samples, and hinder the ability of your clients to read your pricing menu.

LCD/Pasma Television

Generally thought to offer the best quality image for the client. Light in this case is not reflected off of a screen, but is projected

through pixels right to your eyes. A large monitor tends to have a visual impact in a room, and it literally already has a frame around the screen. Many monitors have built in sound systems for slideshows during the presentation. Size does matter in this option as a 60-inch monitor will only show a 30x40 horizontally. A 70-inch or 80-inch monitor would be required to illustrate a true 40x60-inch image. Some have found that these monitors can have lightness or darkness issues when viewed from the side. This can impact your session if your client becomes concerned about the density of similar images. We use a 60-inch television with a wireless keyboard and mouse connected to a laptop set off to the side. We connect our computer to the television via an HDMI cable. This allows us to have a clean table with no cords to trip on.

All three of these choices are viable options depending on your situation. Before you purchase any of these, we suggest you bring your computer or tablet to test the connection, image quality, and side-angle viewing concerns you might have. It is much easier not to buy an inferior product, than it is to return a large one.

| # Projection Software

There are many types of software solutions in the market today for photographers to show their work to clients and help them to place an order. Some are available only as apps for the Apple tablets, some are android based only, and some are to be used on a PC or Mac computer. Whichever software you choose, keep in mind your end goal when deciding.

You control the screen and the sales process. . .

Our goal in this chapter is not to review these products. We are very familiar with ProSelect as this is the only software we use to sell our sessions. It consistently has been the industry standard for photographers worldwide. It provides a great platform to show imagery and also has a robust production engine which saves our studio time in postproduction. Just because we have found that ProSelect works well for us does not mean that these other products are not well put together or could suit your selling process well. Please take a look at all of these and consider which features will help you to sell your photography and are easy to use for the client. In all cases, these products are to be navigated by you, with input from the client. You control the screen and the sales process and your clients are wowed by your images and expertise!

Things to Consider When Choosing Software

- Which product can work on my piece of technology? If you only have a laptop, then the apps do not make a lot of sense unless they offer a computer version of the application.

- Does the product allow you easy input of your imagery?

- Are you easily able to import a room view from your clients?

- Can you show true to scale portrait sizes of their room views?

- Does it have a production component?

- Is the image selection section easy to use?

- Can you download a free trial to see which one works the best for you?

- How do you plan to show the client?

- Will you share the screen of a tablet or laptop, project from a tablet, or laptop onto a screen in your studio, or connect to the client's large screen television in their home?

- What sort of connectors will I need to make that happen?

- What is your budget for software? How is the support? Is the software company likely to be around in five years?

- Is the product a subscription that I pay for monthly or a onetime fee? If subscription, does the company have a history or good upgrades?

Take a hard look at all of these questions and how they might apply to you and how each feature may benefit your particular brand or style. Below is a partial list of some of the most popular software and applications photographers use for in-person sales.

IN-PERSON SALES SOFTWARE AND APPLICATIONS

ProSelect—www.timeexposure.com

Fathom Focus—www.fathomfocus.com

Adobe Lightroom or Adobe Bridge—www.adobe.com

ProofShare—www.proofshareapp.com

Studiopro app—www.studioproapp.com

You Proof—www.youproofapp.com

Preevu—www.preev-u.com

Shoot and Sell—www.shootandsellapp.com

Preveal—www.getpreveal.com

A Standard for Many Years

In the process of developing your sales approach, consider looking into another method. For many years the standard routine for our industry was to shoot a session on a roll or two of film and send the film off to be processed. You would wait two weeks, throw out the blinks and other non-usable proofs, and then show your client their session with 4x5-inch proofs. You would mark with a grease pen the cropping the client would like to have, and send the negatives to the lab with the desired size and quantity.

Capture to Proof to Wall Portraits

This system worked well for many years. It was successful because it allowed the photographer to be the expert, and it satisfied the client's need to hold something. In today's market, the need to hold something of value can be a pre-qualifier for a client. We are not looking to produce work for clients who only want a disc, so they can save a bit of money and print the images themselves. We want to work with clients who want us to take the image from capture all the way through hanging the portrait in their home. Selling with proofs accomplishes that.

This style takes a bit more time and a lot more out of pocket investment than the projection sales process. Today a photographer would capture the session, cull the images, and then upload to their favorite printer. In our studio we use www.WHCC.com for nearly everything we produce. Proofs are printed and shipped back. We normally see every proof-size order returned to us in two days, not two weeks!

Proofs and Pre-Matted Images

Photographers who are working with proofs have been finding success with pre-matting the images. They might have made fifty images at the session, but they are presenting fifteen images in a 5x7-inch size in a matted presentation. This offers the client less choices, but every choice is finished, and the matted look definitely appeals to those looking for tactile satisfaction.

Benefits of Proofs

Some of the benefits are huge. The client can visualize what a finished image might look like. They also usually have the choice to purchase the entire set of proofs and take them home that day. This effect on the psyche of the consumer cannot be overlooked. We are in a society where instant gratification is king. This method plays right into that desire.

There are a couple of discussion points on this process that have to be accounted though. The first one is cost. Even when buying in bulk, the mats can be expensive for a busy studio, and the actual print cost can add up fast as well. Time is not your friend in this process either. Consider the amount of time and effort that goes into actually assembling the pieces or the longer duration of the sales session. Enhancing images that people do not purchase is very risky. If a client does not buy that image, your time is gone forever. You are starting off in a financial hole that takes some work and selling to get out of.

We want to work with clients who want us to take the image from capture all the way through hanging the portrait in their home.

If you do it right though, you can become profitable, have good sales, and work with a technique that is unique enough to differentiate yourself in a crowded market. The potential word-of-mouth marketing from this could be huge. Your clients will tell their friends, and the people they know who are drawn to this artisanal approach will likely become your clients.

33 | Online Galleries

Since time is such an important commodity to the lives of photographers, the idea of online galleries seems to be the perfect answer to an industry who does not usually love to show and sell their own work. Doesn't it seem perfect? You shoot a session, produce your favorite images, and then upload to your preferred online gallery site. The orders come flowing in at all times of the day and night. It is so easy for your client to access their images whenever they want and share them with friends and family all over the globe. Don't negate the fact that no effort is required by you to give your professional opinion or help the client choose the products. Sounds dreamy, right?

Well, it only works in theory. The amount of sales photographers nationwide produce via an online gallery approaches a statistical near zero. We are not saying that some mini sessions, sports teams, proms, or other higher volume type of business model cannot find a way to make this work. We are simply saying that a family, children, baby, pet or senior photographer will have a hard time making a living using this method.

We tried this for some time in the early days of our studio. Days in which we were afraid to offer our opinions as to the proper size of a portrait on the wall for fear they would think we were trying to "sell" them or push something on them. During our trial, we learned a couple of lessons.

Lessons Learned

1. Clients do not place wall portrait orders online—ever. The hard reality is, in the mind of the consumer, 8x10-inch prints sounds huge. We know that an 8x10-inch print is smaller than a single piece of paper, but it sounds big to our clients, and only through illustrating size in relationship to viewing distance does it make sense that bigger is better.

2. Clients do not need to place portrait orders if they can already show their friends all the portraits without buying them. As Julia Woods once told me, "It's like buying a dress for an event and leaving the tags on. You can wear it all night and your friends see you in it, but you can return it in the morning."

 Online galleries offer the same sense of satisfaction of showing your family portraits without the ability to acquire the images for future generations. This is a disservice to those who trust us to make portraits for them. Files are for sharing; prints are for preservation.

3. Lastly, and most importantly, clients almost never find the time to even look at the gallery. People lead increasingly busy lives with impossible schedules. Finding a quiet time to sit down, compare sixty-three images as to which ones are the best

and which ones are not is nearly impossible. Then, add in which size, crop, shape, and finish, and you have a recipe for a gallery that will never be opened. The saddest part in this situation is that no one benefits from all the work the family has done to coordinate the session, or the effort the photographer has put forth. No sale is made, so the photographer ends up with nothing to show for their time, and the family ends up with no portraits to pass on for future generations.

As a result of the lessons we've learned, we feel online galleries have virtually no place in a successful portrait business.

The amount of sales photographers nationwide produce via an online gallery approaches a statistical near zero.

It is most beneficial to have a dedicated sales room to show your imagery and to guide clients in their purchases. With a bit of time and care, your sales room will be set up to yield happy clients and excellent sales. If a dedicated sales room is not possible for your situation, you can still incorporate some of the following concepts to your sales area.

It is important to display current images that represent what you want your client to purchase.

1. A Large Television Screen Focal Point

In our studio we show our clients imagery on a 60-inch television mounted to the wall. We use this tool as our main focus point in the room and designed our furniture and displays around the television screen.

2. Seating

There are a variety of options available for seating your clients. One option is to place a couch or set of comfortable chairs at the proper viewing distance from the television or viewing screen for your clients to sit and for you or your sales person to sit at a desk or in a separate chair to the side of the client. If using this option it is important that you or your sales person to sit in a perpendicular fashion facing the client. You want to be able to make eye contact with your client and be able to read their body language so you can make sure they are comfortable with their buying decisions. You do not want to be the Wizard of Oz hidden behind the client. A second option—the one we currently use at our studio—is to sit at a round table with the client viewing portraits on a television. This option, while less comfortable than the couch, allows the sales person to sit directly with the client to interact in a more personal way. It allows products such as albums and folios to be shared, and an opportunity to collaborate with your clients as opposed to taking a passive approach taking an order.

3. What to Display?

Another consideration is what to display on the walls. It is important to display current images that represent what you want your client to purchase. You should have a variety of sizes and finishes as well as examples of all of the product options.

4. Clean, Quiet, and Well Thought Out

This is the room where your client will make buying decisions. It should be clean, quiet, and well thought out.

When creating a plan for a portrait session, it is important to keep the end product in mind. We realize that unless you have a pre- session consultation or a crystal ball, it is impossible to know what the end product will be. Certainly it would be great to know in advance that your client wanted a wall grouping with six images and the largest one needs to be a 30x40-inch print. Just the same, these kinds of sales can happen at the sales session when you approach the portrait session with vision.

You want to shoot enough variety to give your clients choices. If you photograph a family session, arrange the family standing, sitting, and with different backgrounds and poses to give them options. Let's say you photograph a family and for the complete family portrait you photograph them in three different poses. They may prefer the third pose over the others which will make you happy you did not stop at pose number two. You want happy clients who love their portraits. Give them options so they can determine what they like the very best. They may decide they like all three poses and buy a wall portrait of each. Allow them the option to decide this by providing the imagery needed to make it happen.

Another consideration when planning a family portrait is to photograph a variety of groupings as well as individuals. Don't forget to photograph the parents together if possible. They often have not been pho-

You want to shoot enough variety to give your clients choices.

tographed together since their wedding. Photograph the children together, but also make beautiful images of the children individually. When it comes time for the sales session, remind parents that individual portraits will be cherished by the children and their future families, and each child may wish to have one of their own when they are adults.

One way to use a wide variety of imagery is to create wall collages with groups of images that together tell a story. This allows parents an outlet for using group and individual images in one space, so they don't feel they have to spread imagery from one session throughout their entire home.

Photograph some close up images and some that are more environmental showing a beautiful scene if possible. Shoot vertically and horizontally to allow the images to be placed in a variety of spaces within your client's home and to allow flexibility in creating wall groupings. If all your images must be cropped horizontally to look best, you are not allowing for a space in the client's home that requires a vertical.

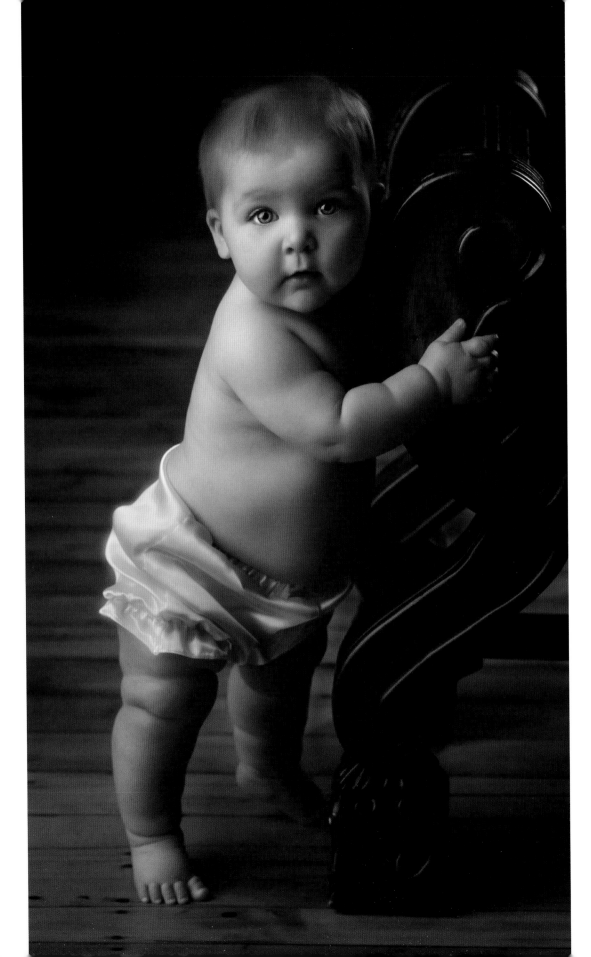

Show What You Want to Sell

A mistake we have made—and one that we see often—is photographers not following the adage: *Show what you want to sell.* Before you can create samples of what you want to sell, you first must decide what you want to sell. That might be the hardest part.

In our case, we want to sell wall portraits. Yes, we do want to sell gift prints, albums, and collages, but our focus in our market is to produce wall portraits for our clients. We have several reasons for this. First, our clients, their friends, and family will enjoy a properly sized portrait for many years over a big 8x10-inch print. We don't want them to invest in wall portraiture because it is profitable; we encourage it so they will love it for years. We do, of course, want our clients to purchase items from us, but not at the expense of function. In other words, a 5x7-inch image makes sense when the intended display area is a desk and will be viewed each day in close proximity. A wall portrait is best viewed larger when the viewer is further away.

Displays Help Client How to Use Images

All of our displays are intended to help the client imagine how to use the images we have made for them. We have different displays in our studio for different product lines, and they change throughout the year. Primarily, we have a cluster of canvas wraps for a larger area, a hallway of traditional matted and framed prints for a gallery look, and our artisan canvasses mounted on Masonite for our most popular look. During our high school senior season we tend to show collages more, as our clients have many image choices from their child's session and are always looking for ways to use the portraits without creating a shrine in their home. Collages help to fulfill that need.

Group versus Individual Portraits

When displaying portraits of children, we prefer to create a display that illustrates each child, instead of a group portrait of the children. If we produce a single print of a group of children, it is far less profitable than producing three portraits for the family. A major benefit

that can easily be lost on the family with this type of display is the dilemma that happens when the children move away. Who gets the group image? We hope our photography is cherished for years to come and eventually will hang in the future household of the child. This is very unlikely if a group portrait is the only investment.

We hope our photography is cherished for years to come and eventually will hang in the future household of the child.

Our approach to the sales session is simple. Help the client get exactly what they want, and keep them within their budget if possible. Because we are a business, one might assume that profit is the only thing that matters. For us that couldn't be further from the truth. We have to make a profit, that goes without saying. We don't mind mentioning this in a light hearted way to our clients during the sales session. Being honest and upfront about our need to be in business next year, to work with them again, to pay our bills, and be a productive member of society is almost refreshing to them. They are used to all kinds of games when it comes to sales. Today's consumers are savvy, and can smell a sales trick a million miles away. We don't believe in or offer trickery of any kind. Our goal is to help!

The Premiere Room

Our process pretty much stays the same for each client. We invite them into our Premiere room. Inform them about the best place to sit, offer them a drink and make sure they are comfortable. If their children have joined them, we start a movie for them or set them up to play in the children's area of our salesroom. At the very beginning of the presentation, we explain that we made

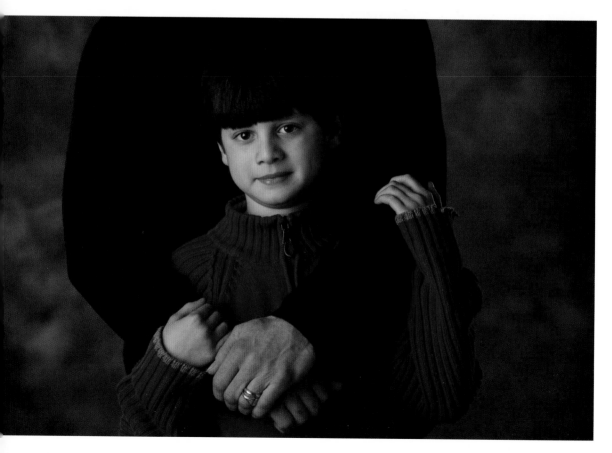

a number of images, and will be looking at them two to five at a time, depending on the pose. We use ProSelect as our presentation software on a laptop off to the side, a wireless mouse, and keyboard so there are not wires, and present the images on a 60-inch LCD television screen.

Culling the Images

We will then pull up two to four images of a similar pose, and ask the clients which one they prefer. Our goal is not to edit the session down to one image. We want to cull the session down to the favorite images of each pose. Through this process of elimination, the client gets to see the entire session and make decisions along the way as to which they prefer. We ask early on if they would like our help. Most are thrilled to have the help of an experienced photographer in choosing their images. In some cases we might disagree with a client's choice, and we are not afraid to inform them that we disagree with their choice and why. Sometimes they agree with us, and sometimes they do not. Either way, this is one of the main benefits to the client—our expertise.

The Slideshow

After we have chosen the best of all the poses, we then show a slideshow of the favorites with ProSelect. We use copyright free music along with the imagery.

If we have done a pre-session consultation, we might ask them which image they were thinking about for a portrait on the wall. We always start, if possible, with the wall portrait choice. We have found that once the main portrait is decided the subsequent wall portraits or gift portraits seem to fall in line. Remember, our goal is to help them achieve what they came in for, not sell them everything we have to offer just for the sale. We are not looking for the client to purchase items that will sit, unused in the drawer for years. We want them to purchase with purpose, and create a relationship that will be strong for years to come.

We simply ask, "What else can I help you with?"

Payment

After we cycle through their order choices and place the items in the cart, we simply ask, "What else can I help you with?" Once we have exhausted their list, we thank them and ask them to come to the counter to check out. We accept all of the credit cards, checks, and cash. Most people do not carry cash anymore, and we have learned if you want a three percent raise, get used to saying, "We prefer checks." By not paying the credit card surcharge, you are saving about three percent on every order. This is huge over the course of a year. Many clients do not carry checkbooks either, so we are happy to accept a credit card.

A good vocabulary can help elevate the opinion people have of you and your business. We are not talking about using puffed up words and carrying a pocket thesaurus in the grocery store. We mean choosing words that help convey your brand to current and potential clients. You will also find that clients will tend to echo how you speak about your work. Be careful in how you refer to your craft and your products. Imagine a client describing your service to a potential client in the verbiage you are using. Does it represent the care that you take in your business? Does it sound appealing to potential clients?

Use words that help support the notion that you are an artist, not a camera operator. When speaking about your work, mention some of the things that separate it from others in your community. Mention the color harmony, the gesture of the subject, the expression, the lines in the image, the strong diagonals, and the intentional composition. By minding your words, you set yourself up to being an expert in your field, and this is another passive way of justifying your prices.

Here is a short list of some words and phrases that might be used instead of other words and phrases that might have a negative connotation.

Take Pictures versus Make or Create Images

Instead of saying, "We will show up around two and take some pictures," it would be better to say, "We will arrive around two and start making your portraits."

Pictures versus Portraits or Images

Instead of saying, "Our pictures starts at $45," it would be better to say, "Our gift portraits range from $xx–$xxx."

Shoot versus Session

Instead of saying, "Hi! I'm here to shoot your baby—where should we do this?" it would be better to say, "Hello, I'm here for your session. Where were you thinking of making these images?"

Kids versus Children

Instead of saying, "You have three kids?" it would be better to say, "How many children do you have?"

Packages versus Collections

Instead of saying, "We have packages that everyone can buy." it would be better to say, "Our collections begin at $295."

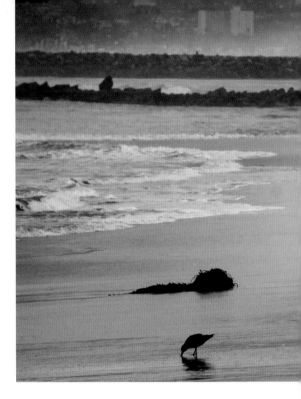

39 | **Emotional Sales**

When selling portraits, there usually is a lot of emotion. If you are a portrait photographer consider this hard truth; people buy your portraits because someone they love is in them. We want to believe that our clients invest in our time and efforts, so that they have an original piece of art. Unless there is another compelling reason, clients will buy portraits of people they love to hang in their home. They may choose to display landscape images of a particular place that they have a connection with, but random portraits are not common.

As we accept this truth, we must conclude that sales and the investment of portraiture is an emotional decision. Even buying commodities can be emotional decisions for the buyer. Some buyers have fears based on spending money, while others can become euphoric. Have you ever heard the term *retail therapy*? Consumers get a high from consuming some products and services. Although we are not trying to capitalize on people's emotions, it is important to understand what is, or might be, going through their heads when investing with you.

Most consumers feel one, or a combination of these six emotions, when purchasing your products: fear, pride, shame, greed, envy, and philanthropy. Knowing that some of these emotions could run high during our sales session, we are careful not to exploit them, but to use them to mutual advantage. We want to sell portraits, but we also want the portraits to be available to be enjoyed today by the client and by future generations.

Here are a few feelings your clients might experience without you knowing.

Fear of Loss
- If I don't buy these portraits today, I will never be able to buy them.
- If I spend my money today, I will not have enough money to pay my bills.

Pride
- I can't wait for my family to see how great my family looks. I want to show these on Facebook so everyone can see what a great group of kids I have.
- I can finally afford to invest in family portraits.

Shame

- If I buy a big portrait, my family will think I am flashy.
- I wish I was twenty pounds lighter in this portrait.

Greed

- If I don't take advantage of the discount today, I will be losing money on my purchase.

Envy

- I wish I could have a portrait that big.
- I wish my family looked like "that" family.

Philanthropy

- I am buying these so they can be available for another generation to enjoy and feel connected.

- I am purchasing extra copies of prints to give to each of my children.

These examples are not the only feelings your clients are having, but they are certainly thinking some of these thoughts. Knowing this ahead of time can help you to see where you clients are coming from in some of their responses and buying decisions. Put yourself in their seat for a moment and consider how you might be able to help them overcome some of these emotions, and be certain their true needs are being met.

Your portraits will have the greatest impact on your clients the first time they view them. For this reason we suggest you encourage your clients to schedule one premier appointment to view and purchase their portraits at one time. You may believe that we suggest this for selfish reasons wanting to maximize sales by pulling on heart strings? Well of course we want to maximize sales as we are in business to make a profit; however, this approach is mutually beneficial to both the photographer and the client. We have found that clients who are unable to make a decision and schedule a second appointment to review images

Tell them that all decisions makers should be present for this appointment.

buy with their heads only and leave many of their precious images behind. We want clients to buy with their hearts because it means they are allowing themselves to retain all the precious memories captured for future generations.

In an effort to minimize multiple premier appointments we feel it is necessary to educate clients from the beginning. When scheduling the premier appointment, educate your client that this is the time when they will review images and make their purchase. Encourage them to measure walls and look for spots where they might hang portraits. Tell them that all decision makers should be present for this appointment. If you use Proselect Software, tell them about your ability to import room views into their album if they send you pictures of their walls. Educating your client helps them to come prepared, saving you both time and allows them to have the lasting memories they will cherish for years.

41 | Overcoming Objections

During the course of your business, you will need to learn to work with people, and help them to overcome objections in many aspects of your studio. Overcoming objections without conflict is the key. Some clients come to us and want a specific background or pose that we know will not be the right choice for their particular outfit or family. In cases like this, we simply make the portraits that they request first and ask them to humor us for a different background or pose. We take care of their needs first. Once completed, they are more open to letting us try something we have in mind. During the sales session, we, without bias, show them their portraits and let them decide. More often than not, they move their thinking to our suggestion. We overcame their objections without any conflict.

There are a several objections that tend to come up in the sales room. These really are stalling tactics and are designed to put off a decision, and are usually triggered by fear.

We have included a few of the sentences we hear, and a response that at least allows the client another option beyond their statement. These can work to help you out and the client, but occasionally a client has made up their mind, and we need to respect their decision.

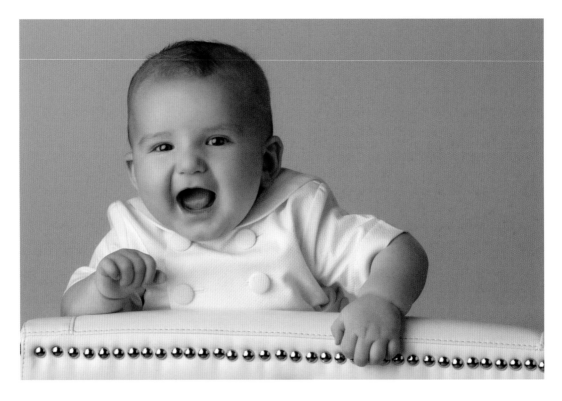

Overcoming objections without conflict is the key.

I need to check with my spouse.

A stalling technique usually prompted by the fear that they are making a bad choice. We tell all of our clients that the decision makers should be present. We simply ask the client if we should stop right now and reschedule around the spouse's availability? We then ask if the spouse likes to make these types of decisions. Is the client normally involved in the same type of decisions and does the spouse wait for them? In many cases the client is reminded that the spouse does not love this type of shopping and can continue on without them. Remember, we are not trying to convince them. We are trying to help them get their choices done in a timely manner, and allow them to get their portraits on the wall as soon as possible.

It's not a good time, financially for us

As human beings with budgets and a family, we completely understand that family financial life can be messy. A simple nail in the tire can be an $800 afternoon that was not planned and can add stress to a portrait session that wasn't there several hours ago. To accommodate the client, we might mention that we typically collect the entire purchase, but since they have had some unexpected expense recently, we could start their order with only half down. We can then take care of the other half upon pickup. As a note, we do not give the client the product until they have paid for their order. If they would like to have three months to pay, we would be happy to split the payment into three, but we do not do any artwork on images until at least half of the order is paid.

I need to go home and measure

This comment shows up more frequently. We find that once we have showed the client their portrait on one of their walls, correctly sized and calibrated, it can remove most of those objections. Still, it can come up. To handle it, we address several of their fears, such as lost money or loss of choice. We can combat these fears with a guarantee. We ask them to make a decision about the size today. When they go home, measure the space, and let us know later that day or the very next morning if the size they chose is appropriate. If we don't hear from them, we will move forward with the order as stated. This way they don't have to find a time to come back in to the studio until they choose their frame. If the image is the wrong size, we will gladly replace the image with the correct size. The guarantee removes the fear, and our client leaves knowing that they are going to be taken care of in the end.

It's no doubt that sales incentives have been driving sales behavior since the beginning of time. Our desire to drive sales helps our profitability, efficiency and happiness with the products we produce for our clients. It also helps the client make decisions in a timely manner so they do not agonize over them. These incentives often help to push the client to enjoy their portraits much earlier than they would have if they let their objections get in the way. Incentives can act as motivations to overcome objections.

Incentives do not always translate as discounts. Discounts are problematic as they tend to train clients to wait until there is a discount to make a purchase. Our studio does not offer discounts as we do not want the price decrease to impact our brand. We do, however, offer incentives to help encourage buying decisions.

Our most successful incentive comes from the desire of our clients to want a print of all of their favorite images. We offer a proof set of a full session once the client has crossed a particular investment threshold. A proof set is one, unretouched 4x6 of each of the favorite images from their sales session. We allow them to choose up to twenty-five images for their proof set. We explain that they are not retouched, unless they are ordered elsewhere in the sales process. They are ideal for remembering the entire session, but are not ideal for framing as there is not artwork done to the proof set. We have had success mentioning this, both at the beginning of the sale, and when they are a few hundred dollars away from meeting the requirement. We make it clear that it is in fact a sales incentive. If they are interested in receiving it, they might want to add a few items to make up the difference. Ultimately, it is up to the client to apply a mental value to the proof set. If they were to buy twenty-five proofs, they would end up fairly close to being eligible for the incentive all on its own.

We have seen many studios find success with a few other ideas as well. Let's take a look at some of them.

Black Friday Sales

Who doesn't want to have a crowd of clients at their studio on one day to purchase something? As we are a service industry, we work hard to make sure that each client gets their time with us. With these types of promotions, visibly seeing others saving money is a huge part of the payoff for the client. Consider offering a special gift card sale with an extra dollar amount on every card, or two sessions for one. You buy a session; your friend gets a session free! twenty-five percent off ordered images. Clients can reorder already worked up files for big savings. Whatever works for you. Keep in mind that very few will probably take advantage of it, nonetheless be ready for an explosive response as well. Reserve the right to limit quantities or the initial time frame.

Portrait Gifts

We have seen success with ordering a photographic gift of some sort when a client breaks a barrier. Personalized lockets, small albums, small framed pieces, and handbags are all gifts that you may find in our industry for a range of investments. Be cautious about offering these type of gifts at too low of a threshold. For instance, if your cost of goods sold (COGS) and cost of doing business (CODB) are in a profitable range, then a $1200 sale will likely have about $400 in profit for you to pay yourself and your family. If you choose to purchase a gift that costs $70, you are giving away about twenty-five percent of your pay to cover the cost of the gift. The gift should motivate the client to reach into another level, past the average sale, not up to it.

First Session Orders

Some studios offer a discount at the time of their first ordering session. If a client chooses not to order at that moment, they lose the discount. The key to making this work financially for the studio is that their à la carte price menu needs to be priced higher to accommodate the discount. If you offer a 10 percent discount, then your prices need to be raised by 20 percent to cover the discount. If they choose to order at the second order session, the studio will see an extra 20 percent on the sale, but will likely have a reduced sale. The impact of the imagery is highest the first time the portraits are viewed.

Expiring Discount

Wedding photographers have long used a discount that expires after a certain time to encourage participation. The discount might be quite large, but only be available for a week to encourage event attendees to purchase early. Statistically, once images are viewed, the chances that they will be ordered and installed in a home drops dramatically the longer it is from the first viewing. Simply put, people don't buy what they have already had a chance to see.

Consider the theories behind some of these buying incentives and create programs that represent you and your brand.

43 | Framing

You may have noticed that we tend to see our business as a way to use our talents to provide a living for our family, and to provide a service for our clients that they and future generations will treasure for many years. Framing is one of those segments that benefits our studio while also offering a huge benefit to the client.

When making imagery for our commissioned sessions, we are visualizing how the images may be used. In our case, our favorite presentation and finish style is a canvas print mounted to Masonite placed in an understated frame. It does not mean that we push this finish. We produce a lot of it because we really believe in the benefits of this combination. This does not mean we do not sell framed and matted prints, gallery wraps or loose prints. We produce a lot of different finishes, because we aim to please our clients.

Framing can add a significant amount of profit to your sales session while taking the burden off your client's shoulders. Do not underestimate the value of a one-stop shop. If you are not offering framing, consider that your client needs to take your product and consult with another professional as to which frame looks best. Your pre-visualized *look* is now in the hands of someone who doesn't share that view. You also run the risk of devaluing what you do as many clients who leave the studio without a frame

We are visualizing how the images may be used.

tend to not display the image—ever. It sits in a box, somewhere in the home because it is not framed. Our society is busy, and this simple step is just one more thing that is spoken about being completed each weekend, but there never seems to be enough time. Often we have clients who have come to us to photograph their second child several years after their first child's session. If we did not produce a framed portrait, they are likely to ask us about framing both sets of prints. To us, that is sad, as it is several years that they have not been enjoying their portraits. We are happy to help, but would have loved to have their prints hanging years earlier.

Choosing to offer framing is not difficult and with the purchase of a few tools, a little bit of practice and some patience, you can be framing in just a few days. We suggest you do not try to compete with your local framer in moulding samples. Start by choosing twenty-five mouldings from a frame company you like. Our favorite frame supply company is GW Moulding in Atlanta. We have worked with them for years, and they

stock only frames that compliment portraiture. We order the frame cut and joined to size, so we only have to assemble the frame when it arrives. You could choose to work with a local framer to provide corner samples to you and hire them to do the assembly. You could probably arrange a wholesale rate.

By offering framing you can make your clients life easier, while increasing your bottom line.

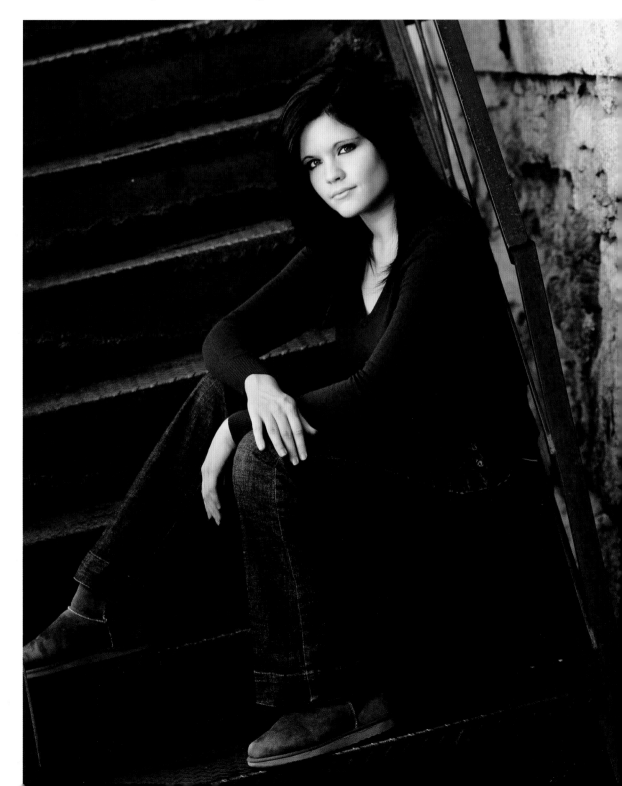

Sales positions are considered to be one of the hardest jobs to fill in many industries. It seems there is a negative stigma attached to the salesperson. As people, we tend to take that to heart and shy away from situations, real or imagined, that make us feel like we are selling.

Our Goal Is to Help

This is why our goal is to help, as opposed to sell. Of course, we need to sell in the sense that our clients need to complete their purchases for us to remain doing what we love, and for the client to receive the portrait that they really want, as well. However, we don't need to push too hard to make

that happen. Every photographer will develop his or her own comfort, or discomfort level with this. We have found that whether we are in discussions about a session, or in the middle of choosing a size for a wall portrait, the best way to break the tension of the sale is to simply ask for it.

Discuss, Make Offer, and Repeat

During a consultation where the client has not committed to book us, we might ask, "Would you like to reserve your session date now?" In most cases they answer in the affirmative, we book the session and everyone is happy. If the consumer still has questions or concerns, then we happily answer and discuss. During a sales session when the client is undecided between two sizes, we focus on the size we think would work best for them. We repeat the choice back to them, and say, "A 20-inch portrait—would you like to make that official?"

Ask Yes-or-No Questions

In both cases, we are asking yes-or-no questions. Essentially we are asking them for a decision, but not in a way that could be construed as high pressure. In many of these types of decisions you need to only ask for the sale to get the results you are looking for.

Remote Sales Session

We approach our sales sessions in a way that will benefit the client and help our studio to prosper. We live in an area that people travel to for vacation and weddings. Although not a traditional destination area like Lake Tahoe, Florida, The Outer Banks, and Jackson Hole, to name a few, several times a year a client reserves us for a wedding or an extended family session. Our business model is one that we do not just provide a disc and saddle the client with the burden of choosing all of their images, retouching their images, and finding a way to print them on their own. We offer in-person sales on all of our sessions, even those who live out of town. There are a couple of ways to accomplish a sales session without posting an online gallery or just giving them a disc they will never use.

When a client calls about a session and they are from out of town, we clearly explain that we will be photographing their session at their desired time and then find

Once their order is placed, they go right back into vacation mode and are thrilled when their portraits arrive a few weeks later to their home.

a time, possibly right after the session to premiere their images. We shoot RAW and JPG, and create a ProSelect Album with the JPG image files. We can usually download the images and cull them into the best of the session in about ten minutes. We then have a couple of choices. If on location, we can use our laptop and have the parents, or the decision makers sit with us and make their choices. We have also had great success with connecting to a large television in their home or vacation rental to choose the images and place their order. Once their order is placed, they go right back into vacation mode and are thrilled when their portraits arrive a few weeks later to their home.

Another way to work with a client to give them the best customer service and your expertise is through a screen sharing service like join.me. There are many other screen sharing services out there as well. Some are free and some are a subscription service

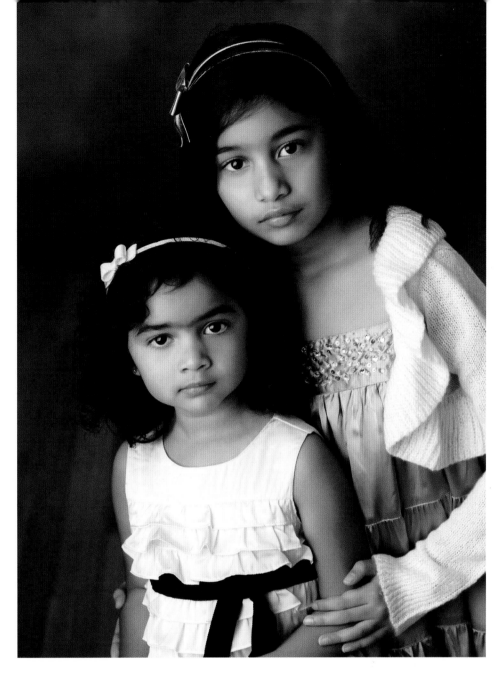

based on your anticipated amount of attendees. We typically only need to host a webinar for one user. Use ProSelect, or your favorite presentation software to go through the sales process while on the phone. This way, you can still add your expertise to the sales session, control the session, provide the highest quality of customer service, deliver great memories of a family vacation, make a profit, and not saddle a client with the burden of learning Photoshop software.

Marketing and Promotions

As a business owner we wear many different hats. We have many different jobs to do and a new hat for each job. As with everything in life, hat styles come and go, but one hat that you must always wear underneath every other hat is that of marketer. You can never stop marketing your business until you are ready to close the doors.

We consider marketing to be everything you do to develop your product thoughtfully, spread the word of your services and products, and speak about your work. Marketing is researching what your clients' needs are and fulfilling their wants. Marketing is at play with every interaction your client has with your company including receiving a direct mail piece from you, the tone by which they were greeted on the phone or upon entering your studio, the functionality of your website, and even what you are wearing when they run in to you at the grocery store. When your clients see or meet you for the first time, you are marketing. When you see a

client from five years ago while photographing a wedding, you are marketing. Marketing is the message you want to share about your company.

Branding Is Not Marketing

Branding is often spoken of as marketing. These two words, although used together all the time, are not the same thing. Branding is who you are, not what you sell. Branding is a promise that you will back up what your marketing says you will do. It is how you are perceived in your community. It is the feeling that people get when they see your logo or speak to their friends about your business. Your brand is your bond. In your community, everything someone might know about you reflects on your brand.

In the chapter 47, Marketing Introduction, we say that you never stop marketing, and although that is true, your brand goes beyond the individual value of your logo, color scheme, tag line, business cards, marketing materials, website, and social media campaigns. It is the intangible quality of you, as a business. It is very important to separate in your mind the idea of branding, marketing, and logos. Although they play nice with each other all the time, they are not one in the same.

Visualize Your Brand, Identify Desired Attributes, and Create Your Entity

Before you create a brand, you must first visualize what your brand should be. You need to find yourself as an artist and business. Work on the messaging that might attract your target client. Figure out what

you have to offer beyond what others in your market offer who are competing for the same client. Determine your unique selling proposition. Search deep and figure out the "why" about your business. Why do you do photography?

Once you take stock of yourself and figure out the *why*, your brand can start taking shape in your head. You are welcome to write down all of the attributes you want your potential clients to say and think about you, and then start creating this entity.

Your logo is not your brand. Your logo is a graphic identifier of your studio. It is vital that your logo represent you, your studio, and your brand well. Is your logo difficult to read? Avoid busy logos that distract your client from knowing at first glance what your business name is. Always keep the vector file for your logo art work even after you think you have created every size and color combination for every day uses. You never know when you will need to go back to the original file for a new project.

Besides your logo reflecting who you are, it should appeal to your target client. The logo for a high volume sports photography studio should have a very different feel from a low-volume fine-art portraiture studio. Both studios can have high revenues, but the target audience and overall message of the studio is different, and the logo should reflect this.

Your logo is a graphic identifier of your studio.

Here are some considerations:

- Color scheme
- Impact?
- Does it stand the test of time?
- Can you change the orientation of the logo for varied uses?
- How will it look on your prints?
- Does it hold up in black in white for newspaper use or when being faxed?
- How difficult is it to make a dye for packaging?
- Is it masculine or feminine?
- Readability.

Marketing Materials

Creating interesting and cohesive marketing materials is a smart business move for a variety of reasons. Imagine each piece of your marketing materials to be members of a team. They should all wear the same uniform and be ready to work together to get a job done. This means creating business cards, marketing postcards, stickers, appointment cards, brochures, and stationery with a letterhead that have a uniform look and feel, and that represent your business well. These pieces should reflect your brand and be appealing to your target client.

You may find it is worthwhile to hire a graphic designer to help you create your look or perhaps consult with a designer to create a clear vision. Until you decide exactly what message you want to send to your clients, it will be difficult to accomplish this successfully. However, once you have identified your ideal client and identified your brand, the process of creating these marketing pieces will become easier. You will want to keep your color scheme consistent. You will also want to keep the voice in your message consistent. You must list your business name, address, phone number, and website on each piece. These may sound like obvious items to include but trust us, they can get forgotten. You should not include your Facebook contact on your marketing pieces as it is redundant and unnecessary.

You will want to consider printing some items in large quantities when appropriate. This will save on printing costs and save you time. Try to keep your marketing pieces free of dates when possible as including dates will limit their shelf life. Another option is to print a piece with an entire year of important dates and studio promotions.

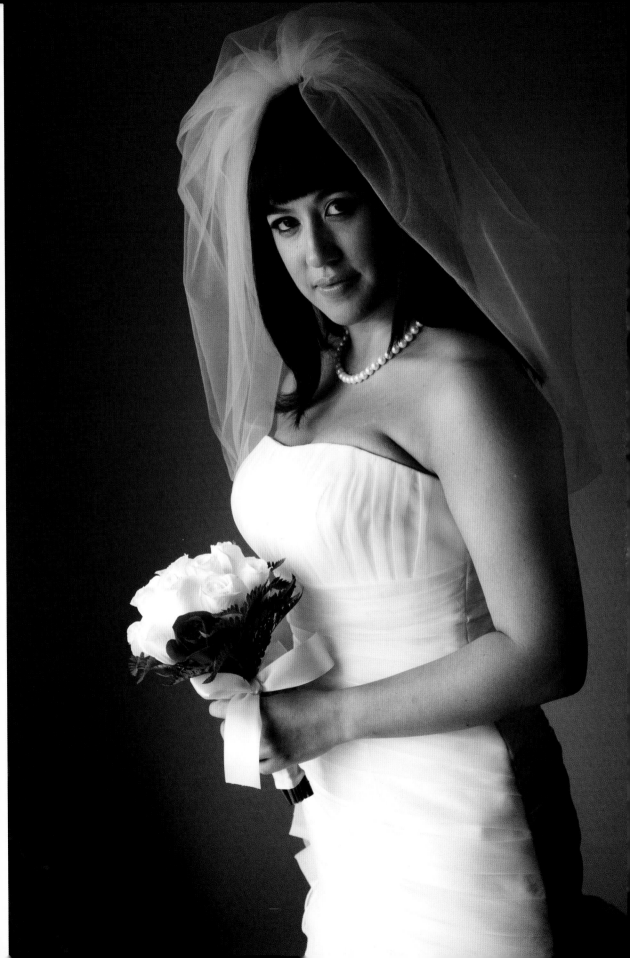

Marketing partnerships can be a very powerful item in your marketing portfolio. They can extend your reach tremendously, if it is planned well. The concept of developing your own marketing partnerships begins with determining your target clientele. Once this has been determined, your next objective is to spend time identifying other businesses that cater to your target client.

It is important that you approach any business with an offer that is mutually beneficial. Let's use our studio as an example. Although we are thrilled to produce portraits for people from all walks of life, most of our clients are women from middle- to high-income brackets. Knowing this, we identified high-end salons as good marketing partners. We both cater to the same clients and can help each other grow our businesses.

The concept of developing your own marketing partnerships begins with determining your target clientele.

We identified specific salons that matched our style and developed a relationship with these salons. If we did not develop a good rapport with the salon owners or stylists, the effort would be ineffective. We never ask for their mailing list. We simply want the ability to reach their clients with our artwork at their salon. We wish to hang portraits on the wall and place albums on their coffee tables.

This visual access allows conversations to happen about our work naturally helping us to build our brand in our community. Rarely does a conversation lead directly to a booked session. It does, however, become a touchpoint in our community. People tend to need six or more introductions to make a connection unless they are already in the market and searching. In exchange, we can offer to photograph their salon or perhaps their family or children. As stated above, the exchange must be mutually beneficial.

Quick and Inexpensive

A big part of marketing is getting people in your community to know that you exist. There are a lot of ways to do this. However, it takes time and in most cases money. We have found that placing images around our community was a quick and fairly inexpen-

sive way to attract new clients and remind previous clients that we are around and available to make new portraits for them.

We have tried a couple of display options with varied success. All of them have had potential, but for a variety of reasons, some tend to be more successful. The opportuni-

This works well in vacant store fronts in malls and where other businesses that have good traffic.

ties that require a payment are usually the most successful ones. Let us share some examples of our attempts.

City Campaigns for Artists

Our city hall offers an "Art in the City" campaign in which artists, for a small fee, decorate the walls of city hall to display and promote their work. This did not, on its own, book us a single session right away. It did however introduce our name to many local residents. Several years later as we discuss with our new clients how they heard of us, many mention that they first saw our work in city hall. It takes several marketing impressions, and then a need of the client to get them to call. This was one of them.

Empty Store Fronts

On several occasions, we have placed our photography in empty store fronts. This works well in vacant store fronts in malls and where other businesses that have good traffic. Consumers see the display and have a positive reaction to the imagery. It can be no cost to the studio, or a small fee might be appropriate. It does need to be clear that the studio is not located at that location, or that it is not moving there. We have used a large sign that mentions to visit us at our studio, and we list the address prominently. Additionally, this can be good for the store's proprietor, since the portraits attract attention to an empty storefront and might help to rent the space.

Be Seen by Potential Clients

One of the fastest ways to market your business in nearly any community is to be in front of potential clients. If you choose to stay in your home or studio, and expect the phone to ring simply because you post a great image on Facebook, you will likely give up on photography as a serious way to make a living. We know this sounds harsh, but a huge part of our success is our willingness to get out of the studio and sell our business to the community.

By becoming involved in your community, you will be building relationships with movers and shakers in your area

Build Relationships

People like to do business with people who are like them. Clients who are financially well off enjoy giving their time and resources to help their community. By becoming involved in your community, you will be building relationships with movers and shakers in your area. People like to connect you with others who might need your services. A firm handshake and compelling conversations in which you do more listening than talking can lead to far more business for your studio than a billboard on the highway.

Make Your Business About Helping Others

It sounds selfish to be involved to help your own business, but if you remember, we believe in making our business about helping others first. Beyond growing your business, you will likely create a great group of new friends outside of your current circle of influence.

Groups and Places for Community Involvement

Here are a few suggestions of groups and places to get involved with that might help get you going and do great things for your community. First, consider speaking at or joining your local Rotary Club, Lions Club, Church Group, or Chamber of Commerce. Next to consider, your local soup kitchen, food bank, women's shelter, local theater, or local chapters of a national organization all need your help. You might be able to help them with your talent in photography, while others groups might need you to do something completely different.

Giving back to your community will not only help you grow your business, but will pay big dividends in the long run for your local area.

The concept of becoming the expert in your community is one that will be beneficial to both you and your client. It will be beneficial to you, because it will cause you to grow in your industry, and because it becomes a low cost method of marketing. It will benefit your client because when you learn more about your industry, you become a better resource for your client and a better photographer.

So how do you become the expert in your community? You can begin by becoming a member of your local, state, and national professional photographer's associations. We

Learn as much as you can about your industry, and commit to an attitude of continued learning.

encourage you to join Professional Photographers of America and to follow a path that leads to your Master of Photography degree and your Professional Photographer Certification. Learn as much as you can about your industry, and commit to an attitude of con-

tinued learning. We have always believed that if you want to bring your level of knowledge about a topic to the next level, you should agree to teach about it. It goes without saying that the more you know about your craft, and the more you know about your industry, the better able you will be. It will give you the motivation to dig deep and become an expert in that topic. Contact local charity clubs, town library, moms groups, or art associations. Speaking to these groups will help you spread the word about your business while providing a genuine service to the community at no charge.

All photographers want to find the perfect way to market their business. Charitable marketing is not the perfect way to do this, but if done correctly, you can raise a lot of money for needy charities, and introduce your studio to potential clients all over your region.

Auction Events Hosted by A Charity

We have found one great way to get our portraits in the hands of new clients is to partner with a charity who hosts an auction event. There are many ways in which this method can raise a lot of money for the charity and create a steady stream of new clients. We prefer to participate in two different ways.

We use session certificates and gift certificates towards a session and wall portrait.

Offer Session Certificates

With session certificates, we donate ten studio sessions to the charity. We produce a sign-up sheet for the silent auction, and attendees purchase the session at face value and the charity keeps all the money. We then send a gift certificate, valid for a session to their home. Usually we sell all ten certificates. We

have also had great success with this method at a live auction event. The auctioneer still has the ten certificates, but talks up our studio before offering all ten at once. The first ten to raise their numbers win the auction, and we contact the winners in the same manner.

We have also had good results in offering a live-auction item of a session and a 24-inch wall portrait. We have never felt that the offering of a session and an 8x10-inch print felt like much value, and the point of the auction is to raise money for a charity, so we offer our standard-sized wall portrait.

Get Your Product into The Community

This helps by getting the products we know that our clients will love, into the community. Friends of the patrons will see the work and hopefully become interested in asking us to make a portrait for them.

In both cases, we gather the names from the charity of the winners and send our marketing material and certificates to the winners. We do not rely on the charity to do so. After a big fund raiser, the details of who won an item can easily get lost, and it could end up reflecting poorly on our business if the auction winner never received their certificate. This is why we are adamant about handling the contact and following through on our end. Going out into the community like this will help you get your studio name out and do great things for deserving charities.

Since the inception as a college bulletin board, Facebook has changed how the world communicates and obsesses over the nuances experienced during some of our acquaintances' daily life. We have seen huge tech breakthroughs, but most will admit that Facebook has changed the world.

In a few short years, Facebook marketing went from studios posting a few images and watching as the phone rang off the hook, to what many describe as a near fruitless endeavor to engage people in our brand for free. Yup we said it—free. That is probably one of the largest draws of Facebook marketing. Photographers are notoriously cheap when it

. . . most will admit that Facebook has changed the world.

comes to marketing, and Facebook was a great vehicle for potential client engagement. Like any new phenomenon, excitement wears quickly, and it becomes harder and harder to create impact in a vehicle that allows anyone else to have the same visual impact that you have.

Pay Per Click Ad Campaigns

Some studios have had some success with pay per click ad campaigns. We have not found them to be successful. It might be the type of studio or the brand we represent does not connect well with the masses that are active on Facebook. That being said, we still feel a Facebook presence is important on the chance a potential client finds us there. It is also one of many touch points clients can interact with us.

Our Facebook Business Page

We have a business page on Facebook. It lists our phone number, address, website, and even includes a map. We can post testimonial videos, client photos, and general messages to those that like our page. We are not driven by

like numbers as so many profiles are not real people. We also do not ask other photographers to like our page. They are definitely not our target market, and since we are not looking just for numbers, we focus on quality.

Post Images and Friending

We use Facebook as a way to post images of clients who want their images on Facebook. We place a logo over the image on the left or right and post the images on our business page. We ask our clients a few favors while on Facebook. We ask them to like our business page, friend one of us personally, and fill out a review of our services. We tell them, "If you are happy with your portraits, tell your friends, if you are unhappy with something, tell us. We can't address problems, unless we know about them!"

The reason we ask them to friend one of us personally is because currently, you cannot tag someone in a photo on Facebook unless you are friends. One of the only benefits is for the tag to be placed so your client's friends can see their image in the newsfeed.

We only post images after the client has picked up their order. We do not post sneak peeks, nor do we post images that the client did not order prints from. It simply is just not profitable to pull an image, retouch an image and post the file just for Facebook.

We have had great success in using Facebook for all intents and purposes as a blog. We let all of our Facebook friends and business followers know what we are doing. We mention cool things that are happening with us professionally and personally. We do not mention hot button topics like religion or politics. One thing is certain about Facebook and its effectiveness, it will change for sure.

Beyond the realm of Facebook lies the list of endless social media sites and experiments. There are many ways for you to connect with or have an impact on potential clients. We will likely see a nearly endless parade of new social media sites come and go over our lifetime. Each will be essentially the same, and each will promise to be totally different. Having said that, there are two other social media engines that we are fond of, and relate well to the photography industry. These are Pinterest and Instagram. Both of these are very image heavy, which helps to represent our trade well as we thrive on imagery.

Pinterest

Pinterest is a great site to showcase a variety of color schemes, clothing suggestions, locations, props, and more—all elements of your sessions. We certainly can post images of clients; however, it seems to be most effective when your piece inspires someone to action, or to pin it to their Pinterest board. This social action is seen by followers, and if they like something, they will pin it as well. This can explode quickly and offer the original poster a fair amount of exposure to their business.

Instagram

Instagram is nearly a photo-only site. It allows the user to upload a photo from a phone and create an effect that the user would like to share. Instagram photos are square in nature which looks very different than your normal Facebook image. They are shared much like a Facebook photo is. Photographers generally use Instagram as a way to show pullbacks or other things pertaining to a session. They are not usually finished images in this particular social media. One really interesting tool that Instagram offers is a fifteen-second video option. This is great for the parent of a newborn to see how you talk to babies or for a high school senior to get a feel for how you might direct them during the session.

Although not as popular or as powerful as Facebook, Instagram and Pinterest are currently valuable pieces of social media.

For years, the advertising community has widely held that implied endorsements, actual endorsements, and referral—word-of-mouth—advertising are some of the most effective tools in a business's marketing arsenal.

In our studio we use all three in a variety of ways. We try to always produce a quote from a client giving an actual endorsement on brochures. This brings a real review from an actual client. On our website we have a "raves" section, where we post client letters and thank you notes they have shared with us. This can be an effective method of showing our potential clients that we are good enough at what we do, that our clients are moved to share their positive experiences with us. Historically, it is much more likely that consumers share negative stories with businesses, so a positive one stands out in the mind of a potential consumer. It can be extremely effective if the potential consumer happens to personally know the quoted client.

Implied Endorsement

Implied endorsement is very effective as well. You will see this in your studio when one of your clients recognizes another client on your wall, in an album, or on your website. Depending on the feeling they have for your client, it can be very powerful way to pre-earn their trust. "If they are good enough for the Bakers, then they are good enough for me."

Word-of-mouth is your best ally in creating a business that is busy.

By placing clients who are well known in the community on brochures, websites, and social media, you are trading to some degree on their circle of influence. People will know them and associate you with them. In many cases it is an ice breaker to discuss in a general way, your mutual acquaintances.

For our commercial photography marketing pieces, we tend to ask the client if we can include their logo along with an example of the images we made for them. This also falls under implied endorsement, but has the added benefit of promoting, to some degree your clients' business. Logos are easily identifiable and offer the implied endorsement you are looking for.

Reward Clients for Referring Friends

Some studios have found huge success with referral marketing programs. Programs designed to reward clients for bringing their friends to you. We have seen a lot of success with this within the multi-level market business models. People love to encourage their friends to share a similar experience, whether it is a skin cream, a restaurant, or a photographer.

Create a plan to thank your clients for bringing you new clients, and don't be afraid to ask them if they could help you grow your business. This is especially important with the millennial generation as they tend to give more credibility to what their friends and associates think rather than their older counterparts. Ask for a referral. Word-of-mouth is your best ally in creating a business that is busy.

Join a Network Marketing Group

Consider joining a network marketing group. People tend to do business with people they know, like, and trust. so it stands to reason that the more people you know, the better your business will grow. A group like Business Network International (BNI) could help you to expand your circle of influence amongst your community and beyond. These groups meet weekly, and essentially you are asking for specific types of referrals each week. Many of the members in a group will act like your outside sales force with no expectation of compensation. These groups are looking for clients for you and expect you to be looking for clients for the other members. Lastly, find ways to further enhance your Word-of-mouth advertising.

58 | New Clients Are More Expensive

Finding new clients is far more expensive than working with previous happy clients. This can be overlooked when marketing. As a focus, marketing efforts tend to strive to attract the people who have not used us before. Although we need new clients to help our studio grow, we need to nourish the relationship we have with current clients. When developing your marketing plan make sure to leave time, effort, and money available to continue to interact with your current clients.

We have employed several different mediums in our efforts to maintain a connection with current clients. We use direct mail, Facebook, e-mail, phone calls, and hot air

Authentic relationships with your clients must go beyond studio transactions.

balloons. Okay—not hot air balloons, but the others are very effective. We also take time to engage in conversation with our clients when we bump into them in the public.

Authentic relationships with your clients must go beyond studio transactions. They involve knowing the family and their children and taking an honest interest in their lives.

This does not mean that you follow each of your clients and take notes about their comings and goings. It does mean that a congratulations note might be in order when you notice in the paper that their child graduated at the top of their class. A note with a clipping for the paper is an appropriate response. If a family's loved one passes away, a sympathy card might also be a good idea. These tokens are not to create business for you.

Although we mention this in the marketing section of this book, this is about being the best studio you can be. Connecting with your clients and maintaining those relationships will make you feel great and create customers for life.

Great Customer Service IS Marketing

Customer Service Is Alive

Contrary to popular belief, customer service is not dead. Going above and beyond to create an exceptional experience for your clients is the very best form of marketing. When clients are treated well, they tell their friends. When not treated well, they tell everyone. Great customer service is great marketing. As clients are treated to stellar customer service they tend to tell their friends and family. Sadly, customer service missteps tend to have an even greater effect as people tend to spread negative information at a greater speed and frequency than positive experiences. This is reason enough to look at your customer service policies and try to spot the shortfalls before they become issues. Mistakes will happen. When you lose the chance to wow a client with service, don't lose the lesson. Learn from your mistakes and apply them to future clients. Owning customer service issues and not taking the complaints personally is a big step to solving issues in a permanent way.

Help Your Clients

Help clients to carry their orders out to their car or deliver them to their house if necessary. If you speak to your client who mentions they want to pick up their order, but have a sleeping child in their car, offer to deliver it to them at their car. We have been known to deliver orders to people's homes if they live out of town and we are headed in that direction. Clients are surprised when they joke about us coming to their home to hang the prints and

Learn from your mistakes and apply them to future clients.

then we say that is what we do. We are willing to hang the images in the home, and then we make images of the installation to promote it on social media. It is also a great time to discuss future portrait needs and take photos of walls they wish to fill with images from a current or future session.

Make Your Business About Helping Others

Sometimes just putting a concept to words helps to make it more real and more prevalent in our minds. This was the case when many years ago when we attended a workshop given by Tim and Beverly Walden. We learned many things at that workshop. One of the simple things Tim said was that if you make your business about helping other people, everything else will fall in line. We already understood this concept, but hearing Tim put it to words made it concrete and something we could fall back on when needed. So, what does this mean to us as businesspeople? It does not mean giving all of your work away for free, and it does not mean allowing people to abuse your policies and procedures. You can certainly ease your policies to help a client but this should be done at your discretion.

Making your business about helping other people does mean, being courteous and

Making your business about helping other people does mean, being courteous and considerate about how you speak, treat, and interact with your clients.

considerate about how you speak, treat, and interact with your clients. We ask ourselves all the time, if we were the client, how would we like this situation to be handled? It also means allowing your heart to lead the way when appropriate. What we mean by this is, be open to blessing other people with your talents when you see a need you can meet.

At our studio we have a saying that goes like this: If it's our idea, it's free; if it's your idea, its full price. We say this because it is very easy to let other people take advantage of you because you want to be nice. We believe that when a need arises where we feel we can help, we want to volunteer the help and feel very good about that decision. Making your business about helping other people means being kind and considerate, as well as generous when you can. It means

being authentically interested in learning what your clients' needs are and helping to achieve them. It means listening to them with genuine interest when they talk about their lives and being willing to invest your time and energy to get to know them out of respect for them as human beings, not just because you want them to spend money at your studio. It also means that when your client shares his or her portrait budget, you help them to stay within this budget.

Index

Get **AmherstMedia.com**

smarter

from a

book!

- *New books every month*
- *Books on all photography subjects and specialties*
- *Learn from leading experts in every field*
- *Buy with Amazon, Barnes & Noble, and Indiebound links*

Light and Shadow LIGHTING

DESIGN FOR STUDIO PHOTOGRAPHY

Acclaimed photo-educator Tony Corbell shows you the secrets of designing dynamic portrait lighting in the studio. *$37.95 list, 7x10, 128p, 150 color images, index, order no. 2118.*

Flow Posing

Doug Gordon demonstrates his fast and furious wedding photography posing techniques designed to produce great variety even when time is tight. *$37.95 list, 7x10, 128p, 180 color images, index, order no. 2119.*

By the same authors . . .

Lighting on Location

Jeff and Carolle Dachowski show you how to find or create beautiful lighting when shooting portraits on location. A practical approach to a tricky subject! *$29.95 list, 7x10, 128p, 220 color images, index, order no. 2082.*

How to Start a Photography Business

Tracy Dorr takes away the mystery of starting a photography business with tips, tricks, and photos from top pros. *$37.95 list, 7x10, 128p, 220 color images, index, order no. 2115.*

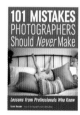

101 Mistakes Photographers Should Never Make

Karen Dórame solves some of the problems that can result in poor images and failing photography businesses. *$37.95 list, 7x10, 128p, 340 color images, index, order no. 2097.*

Photographing Headshots

Gary Hughes explores the process of designing attention-getting headshots that are perfectly suited to your client and their end use for the images. *$37.95 list, 7x10, 128p, 180 color images, index, order no. 2105.*

Smart Phone Microstock

Mark Chen walks you through the process of making money with images from your cell phone—from shooting marketable work to getting started selling. *$37.95 list, 7x10, 128p, 180 color images, index, order no. 2092.*

Wedding Photography Kickstart

Pete and Liliana Wright help you shift your wedding photo business into high gear and achieve unlimited success! *$37.95 list, 7x10, 128p, 180 color images, index, order no. 2096.*

Pricing Your Portraits

Jeff Smith's nitty-gritty guide takes the guesswork out of pricing, helping to ensure the profitability and long-term success of your business. *$34.95 list, 7.5x10, 128p, 140 images, order no. 2053.*